Fiona Killackey

Passion. Purpose. Profit.

Sidestep the #hustle and build a business you love

Hardie Grant

BOOKS

Introduction

Have you ever tried pushing peanut butter through a sieve? It's a frustrating, thankless task.

For many people, running a small business can feel the same way. You put all this effort in, day after day, only to realise your attempts have done nothing but leave you with a big ol' sticky mess.

You see, anyone can start a business. But not everyone can scale one successfully.

It may sound #WayHarshTai but, according to recent Australian Bureau of Statistics data, almost half of new businesses don't survive their first three years. Even if you manage to remain in business longer than your small-biz peers, the opportunity for overwhelm, stress and a general *why-did-I-even-start-this* mentality is ever present.

I've coached hundreds of small business owners across the globe, and taught thousands more through workshops, courses and speaking gigs and, in my experience, what often starts out as something exciting and energising quickly becomes anxiety-inducing and energy-depleting.

It is possible to have the freedom you dream of, with the financial security that you need.

The creative, or 'fun', part of business – which is often what leads people to begin it in the first place – gets drowned out in a sea of admin, invoicing, hiring (and firing) staff, managing deadlines and dealing with incompetent suppliers and ad-hoc, scattergun marketing tactics (which rarely work). You know you want to get ahead, but you end up spending so much time *in* your business, it's hard to find any time to work *on* the business.

It doesn't have to be like this.

It *is* possible to scale your small business without scaling your emotional stress and financial strain.

It *is* possible to actually enjoy what you do, and even – gasp! – wake up happy on a Monday.

It *is* possible to have the freedom you dreamed of, with the financial security that you need.

This book will help you understand what's most important to you when it comes to your business, and how to cultivate more of that so you can create a business that fuels you energetically, emotionally and financially. It's about avoiding the burnout, overwhelm and lack of direction that can make small biz owners believe they have to 'hustle' to make things work. (Truth: you don't.)

Sidestepping the #hustle does not mean sidestepping the work. In order to build a biz you love, YOU have to be prepared to *build* the business.

But doing the work is not the same as 24/7 #hustle.

Doing the work *can* be achieved while also looking after yourself, your family, your community and your interests and hobbies outside of your business. Hustling feels like constantly chasing something that's never quite within reach: an endless, fruitless pursuit of things you don't know if you even really want.

If you are yet to start your small business, this book will provide you with the direction and clarity you need to launch and grow with confidence.

If you have been in a business for some time, this book will show you what's working and what isn't, and how you can increase the former and reduce, or even remove, the latter.

I have worked with business owners yet to launch and those decades in, and I know that the lessons you're about to learn are applicable to everyone.

How to use this book

This book is broken into twelve chapters, each of which relates to one key theme of small business. While you can read any chapter at any time, the concepts build upon one another. For this reason, I suggest you work through the book from start to finish. Once you have read the book and feel you have a good understanding of each area, you can consider it your go-to guide; a tangible tool that you can come back to for a refresher – in any biz area – at any time.

 Throughout this book, you will find templates that can be used to sidestep the #hustle and build a business you love. You will find digital copies of these, free to download, at mydailybusinesscoach.com/purpose. The icon you see here indicates that a digital download is available.

Nestled between the twelve chapters are Creative Q+As. These are short interviews with creative small business owners who have been able to scale their businesses successfully and create a life on their terms, with a business that supports them. I have chosen inspiring founders from a mix of industries – from publishing through to homewares, entertainment and accessories – to give you as much insight as possible into growing a small business successfully.

When I decided to start my own business, I was hungry to hear stories from *real* people who had made it work. Each person interviewed in this book is someone who has inspired or impacted my own business, and is someone who I respect and admire for their ability to make things happen.

How to make things happen in your business

One last note before we dive in.

You have picked up this book for a reason. Something attracted you to it and, if you have read this far, chances are you're hoping it can help you.

Perhaps you're looking to start a business that speaks to your passion and you need some guidance to help motivate you. Perhaps you have been in business for years but you're sick of the stressful, ad-hoc approach you have to running it. You have lost sight of the purpose that drove you in the beginning and you want to be achieving a rate of profit that makes you feel secure.

As I tell my coaching clients, nothing changes if nothing changes.

Whatever your circumstances, I urge you to make a commitment to yourself right now. Commit to reading this book through in its entirety. Commit to working through each activity.

As I tell my coaching clients, nothing changes if nothing changes.

This book is a guide. It is YOU who will have to do the work to transform these ideas into action.

The tactics in this book are akin to a personal trainer providing a client with a meal plan and a fitness regime. It is you, not the trainer, who has to do the work to see the results.

In the same way, this book will – if you commit to it – change the way you operate your business, enabling you to feel more in control and genuinely excited and enthusiastic about your business and its impact on the people you serve.

I wish you all the best as you sidestep the #hustle and build a business you love.

Fiona

Why did you start your business?

One of my favourite songs of all time is the 1999 Baz Luhrmann classic, 'Everybody's free (to wear sunscreen)', the words to which were written by journalist Mary Schmich in her *Chicago Tribune* essay, 'Advice, like youth, probably wasted on the young'.

One line in particular has always stood out to me:

'Remember compliments you receive, forget the insults. If you succeed in doing this, tell me how.'

I agree with Schmich. As humans, we tend to recall the more difficult parts of life (the insults, the stressful periods, the times we felt real shame) more easily than those when we basked in emotional sunshine. It's simply human nature: if you receive 100 compliments and one insult, which will you recall (and possibly spend an entire week worrying about)?

We all have moments when we stop and reflect on the life we have lived so far. And, for the majority of people (myself included), there will be memories of times when we were definitely not the poster child for #LivingMyBestLife – times when we weren't the most inspiring or uplifting person to be around. If you're anything like me, you'll physically recoil when you think back to those moments but, try as you might, they're impossible to forget.

For me, one of those moments goes like this: it was 5 am on a stock standard Thursday. I had gone to sleep only a few hours earlier after attempting, with my husband, to get our then two-year-old son back into his cot. That part had been relatively simple. But as our son began to drift off and my husband and I returned to bed, I couldn't help but lie there thinking about all the work fires I'd have to put out that day. I tossed and turned, considering the mountain of things that hadn't yet been done, the relentless schedule of meetings, and the ongoing hum of office politics that was like a mosquito in a quiet room: impossible to ignore.

So there I was at 5 am, pissed off at having no sleep and feeling a familiar dread about facing the day at work. I got up, showered and slammed some items around the kitchen, annoyed that I was the only one up and feeling exhausted, despite the day having not yet begun. I grabbed my laptop off the kitchen table, where I'd left it after working late the night before, and packed my work bag. I checked on my sleeping son, then told my husband I was off to work.

'Why are you going in so early?' he mumbled, half asleep.

'I have meetings all day. If I can get in by 6.30, I'll have two hours before they start,' I replied coldly.

I ignored my husband's suggestions to stay a while longer – 'Fiona, that stuff can wait' – and stomped down the hallway. I opened the front door into the cold, dark June morning, took a deep breath, then slammed it shut behind me.

My husband hurried after me, asking if I was okay. I ignored him, jumped in my car and skidded off.

The sun wasn't even up yet and I was already hating the day. I will always remember looking in the rear-view mirror at my bewildered husband as he stood out on the street in his PJs wondering what the hell had just happened.

Inside the car, I was angry.

Angry.

Angry.

Angry.

If you have ever met me, *angry* probably isn't a term that would come to mind. In fact, the word I have heard used to describe me more than any other in my career is *empathetic*. But on this day and for months prior, I had found myself snapping at the smallest things. I walked around with this nagging feeling of dread and unease. I spent virtually every waking moment

glued to my laptop or phone, checking emails, following up with staff, refreshing social media posts, checking analytics multiple times a day and worrying I'd never – EVER – get on top of everything.

Don't get me wrong. At work I was still friendly, smiling, laughing with colleagues, giving praise to my team and generally being a good team leader. But behind closed doors, I wasn't myself. I had lost the joy that comes when you truly enjoy what you do. I didn't believe in the products I was marketing and I didn't feel like I was living up to my potential. While I liked the people I worked with and enjoyed parts of the job, it wasn't a position that lit me up. On average, our job takes up at least one-third of our life. This job was slowly killing me.

Around a month after this skid-off-into-the-sunrise incident, I found myself at a life goals workshop. A friend had bought two tickets and urged me to go with her. Lured by the free champagne and a chance to catch up with a friend (I had no real ambition to discuss my 'life goals' with strangers), I agreed to go.

It changed my life.

One of the exercises in the workshop was to write out what you wanted your life to look like in one year. I did the exercise and then, when the facilitator asked what I thought about what I'd written, I replied: 'I want that life. I want to jump into these pages and be living it now.'

Her response shook me: 'Well, you're the only one standing in your way.'

She was right. Nothing about this one-year-from-now goal was outlandish or extraordinary. At its core, it was simply about having more freedom and time, being able to work on projects I genuinely cared about and feeling that I had actually helped people at the end of each day.

While my job was great on paper – good salary, nice exec title, big-name brand – it wasn't fulfilling me emotionally. It wasn't

aligned to the values I wanted to live my life by.

On the drive home from the workshop, I thought about many of my friends and colleagues. They were stressed, burned out and working purely for a pay cheque; there was no love there. When they spoke about their jobs, their words were blanketed in negativity. There was no enthusiasm to get them out of bed on a Monday. Instead, they were counting down to the one annual holiday they would take or the next public holiday that might offer some reprieve. It was no way to live.

I decided there and then that things had to change. *I* had to change. I had to stop choosing security over substance. I had to stop choosing a hefty pay packet over feeling that my work had a purpose. And this change started with working for myself. Controlling my time, controlling the businesses and brands I worked with and genuinely making a difference in people's lives.

I knew I could help people and do work I was proud of. I had worked for almost two decades in senior marketing and content roles across Australia and the UK, and I knew I had the skills that could benefit small business owners. What's more, I could help people see what was possible and provide tactical steps to get there.

As if providence had been moved by my thoughts, the next day a former colleague who now ran his own business emailed me, asking for my help.

He finished the email by saying: 'I really hope you can help me with this, Fi. I'm finding the whole marketing side of business so stressful. Worrying about this shit isn't good for my mental health.'

I come from a family of mental health professionals. My eldest brother is a professor in psychology and a practising psychologist, my sister is a GP who specialises in mental health, and my late mum worked as a psychiatric nurse and,

later, as a social worker and bereavement counsellor.

I know how important good mental health is. Without it, life can feel meaningless.

Reading about my friend's situation made me consider how many other small business owners were out there also feeling stressed and uncertain about how to build and market their business.

What if I could ease this stress by helping small business owners understand and implement marketing? What if I could take all of my experience leading and managing teams and use it to help small business owners cultivate great company cultures?

What if I could use my extensive background in publishing, branding and content marketing to help small business owners truly connect with the people that would benefit from their products and services?

What if I could do all this while setting my own hours and being more available and present for my family?

It felt good. It felt right. It felt worth pursuing.

That was when My Daily Business Coach was born.

Why am I telling you all of this?

Because this is the story of my 'why'.

What is your 'why'?

Before we dive into your 'why' and how it impacts your business, let's discuss what a 'why' actually is.

Whether you're yet to launch your business or you're decades in, there's always a catalyst that pushed you into making the decision to start: a reason that propels you.

Maybe you saw a gap in the market for a product, or you had a horrible experience dealing with a particular service industry. Maybe your decision to start a business was fuelled by a desire to give back to the community, or to do your part for the environment.

That internal reason, that belief that you could change, fix or help through the creation of a business, product or service, is often known as your 'why'.

Consider what your 'why' is. What is the #1 reason you began, or wish to begin, your business? How does this tie into your belief systems?

For example, I believe that when people have good mental health it impacts not only the people they work with and their immediate family, but also their entire community. Helping business owners gain clarity and reduce stress is one way my business output ties into my business 'why'.

If you're finding it difficult to come up with your own 'why', consider the following two questions ...

1. What do you value?

I work with hundreds of small business owners and consult for multinational companies.

Regardless of the size of the business, when I ask clients what their values are, they quickly list off things like integrity, diversity, female empowerment and giving back. But when I ask them to dive deep and really consider a) if those *are* their values or if they just think they *should* be, and b) how well their business is living up to them, I'm met with guilty faces.

It's one thing to state your values, it's quite another to truly believe and live up to them.

WHAT ARE VALUES?

Put simply, values are the guides we use to live and work. They are the beliefs we have around what's right and wrong, what's important and not important and what will, ultimately, bring us fulfilment and satisfaction in life and in work.

 Not sure which values are important to you and your business? Consider the following questions:

1. If you were to die tomorrow (#LetsHopeNot), which values would you want people to say you lived your life by?

2. If you were to ask each of your customers/clients the top three values they experienced working with you, which do you think they would choose?

3. Think about the three people you admire most in your life. Which values do they possess? It may be dependability or commitment. Perhaps they are brutally honest, and you can always trust them to give you their frank opinion on something.

4. Apart from money, why do you want to run your business? Is it about having more time (freedom)? Is it about teaching what you know (education)? Is it about feeling fulfilled (meaningful connections)?

 Another way to discover which values you most connect with is to work through the list of values on the opposite page (also available at mydailybusinesscoach.com/purpose).

First, tick the box next to each of the values you feel a deep connection with. Then try to narrow these down to just ten, and then five. These last five will be your core values.

	TICK		TICK		TICK
ACCOUNTABILITY		FAIRNESS		LOVE	
ACHIEVEMENT		FAITH		LOYALTY	
ADVENTURE		FAME		MEANINGFUL WORK	
AFFECTION		FAMILY		MONEY	
AFFECTIVE		FITNESS		NATURE	
AMBITION		FREEDOM		ORDER	
AUTHENTICITY		FRIENDSHIP		PASSION	
AUTHORITY		FUN		PEACE	
AUTONOMY		GENEROSITY		PERFECTION	
BEAUTY		GRATITUDE		PERSONAL DEVELOPMENT	
BEING THE BEST		GROWTH		PLEASURE	
CALMNESS		HAPPINESS		QUALITY	
CAREER		HARD WORK		RECOGNITION	
CHALLENGE		HEALTH		REPUTATION	
COMMUNICATIONS		HEART		RESPECT	
COMMUNITY		HELPING PEOPLE		SECURITY	
COMPASSION		HELPING SOCIETY		SERVICE	
COMPETENCY		HUMILITY		SPIRITUALITY	
CONNECTIONS		IMAGINATION		STABILITY	
CONSISTENCY		INDEPENDENCE		STATUS	
CONTRIBUTION		INNOVATION		SUCCESS	
COURAGE		INTEGRITY		TEACHING	
CREATIVITY		INTELLIGENCE		TEAMWORK	
CURIOSITY		INTIMACY		TRANSPARENCY	
DEPENDABILITY		INTUITION		TRAVEL	
DEPTH		JUSTICE		TRUST	
DETERMINATION		KINDNESS		VALUE	
ECONOMY		KNOWLEDGE		VISION	
EDUCATION		LEADERSHIP		WARMTH	
EMPATHY		LEARNING		WEALTH	
ENERGY		LEGACY		WISDOM	

2. What do you believe?

If you're finding it hard to come up with your 'why', another question to ask yourself is what do you believe? That is, what do you think is 'true' about the world and/or your place in it?

An example for me is *I believe that nature heals and revives people.* It's why I've chosen, with my family, to live in a log cabin in the bush on the outskirts of Melbourne. It's why my parents took my siblings and I on a long walk every Sunday, and why we went camping every summer holiday.

I also believe that life is short and we shouldn't spend our best years cooped up in a job we dislike. This belief stems from the tragic death of my best friend when we were in our early twenties. The sudden end of her life urged me to question my own, and to ensure I took advantage of every year I got. That includes spending my time doing work that I can be proud of.

Both of these beliefs tie into the way I run my business.

1. The staff I hire are all remote, as I wish to work from my home so I can be surrounded by the bush and go for walks as I please.

2. In addition to working with established business owners, I also coach and teach people wishing to start a business, as I know firsthand how trapped you can feel working for someone else.

What is it that *you* believe? How does this impact your business or the business you plan to launch?

Action

Take a few minutes to reflect on your 'why'.

 Then, in your notebook or an online document, answer the questions below in as much detail as you can.

1. What was going on in your life when you came up with the idea for your business? What was the final catalyst?

2. What difference or impact do you/did you believe your business will/would make and to whom?

3. Why does your business exist (outside of making money)?

4. How have your life experiences, your upbringing, beliefs and values shaped your business?

5. What boundaries will you need to put in place to ensure your biz is aligned with your 'why'?

6. Consider your favourite brand. What's their why and how is this conveyed to you, their audience?

Josh Rubin, *co-founder, Cool Hunting*

Josh Rubin is a photographer, interaction designer and the co-founder and editor-in-chief of Cool Hunting. Since launching as a blog in 2003, Cool Hunting has become the global go-to resource for the latest in design, tech, travel, art, culture, style and music. As the popularity of the brand has grown, Cool Hunting has expanded its offerings to include a retail program, a content studio and a consultancy, as well as hosting one-off travel experiences.

How would you explain Cool Hunting?

Cool Hunting at its core is an online magazine about creativity and innovation, but those words have become a bit diluted these days. We look for interesting and untold stories in the categories of art and design, technology and food, travel, style, music. We're really thinking about our audience, who are typically in some sort of creative profession, and they're coming to us either as a research tool, or just for a bit of inspiration. Our audience is smart, well-read. They've got lots of resources they go to, so it's our goal to either bring them stories that they don't already know, or if we're writing about something that's a little more popular, bring an angle that hasn't been covered yet, whether it's an interview or some other kind of insight.

When did Cool Hunting start?

We started in February of 2003. It wasn't meant to be a business. It was really just a way for Evan [Orensten] and me to catalogue things that we found were inspiring. Evan is my husband and my co-founder at Cool Hunting. At the time that Cool Hunting started, we had very different jobs. That was part of what made it happen. We would come home from our respective jobs and just talk about things that we learned each day.

We wanted a way to keep track of that stuff. My background is in user interface design and user experience, and I'm nerdy enough that I could build a website, so I just built one as a tool for us to keep track of things we were excited about. It developed an audience and became part of the media world over time, not because we tried to, but because I guess we had pretty good timing and there wasn't a lot of content online like what we were making, and people were looking for it.

When did it become something that you and Evan could actually make a living from?

It was about two years in that we realised that Cool Hunting could be a business. At that point, we started to work with advertisers, and we started to develop a better understanding of what it meant to be a business in the media world. It continued to be a side project for several more years, though. Initially it was alongside our different day jobs, and then we started another design firm with some of our old partners from Razorfish, where we worked back in the '90s. Cool Hunting was a side project alongside that.

It was after we decided to make it a business that we started to bring on interns and other people to focus on Cool Hunting full-time, even though Evan and I weren't doing

Photo © Chris Brown

that ourselves. It was about six years in, in 2009, that Evan and I decided that we really wanted to focus on Cool Hunting full-time and took that next step.

What was your upbringing like? Did it influence you in creating a business?

I think it did. My upbringing was strange: somewhat unconventional. My parents were married when I was born, but divorced within a couple years, and I went back and forth between the two of them, and between Vermont and Florida, which are very different states and vibes and experiences here on the east coast of the US. Right out of the gate, I led an unconventional life. When I was eight, they married each other again, which is also atypical. That didn't last very long. They divorced again less than a year later.

I grew up in an unconventional environment, beyond just the marry, divorce, marry, divorce and moving back and forth between different states. My mother is a healer, an intuitive, an astrologer. She does all this really interesting work, but she has always felt that it's not something that she could karmically justify ever charging money for. She had this practice that wasn't about money at all. It was, I guess, more of a 'barter' approach to business.

Then my father is in the glove manufacturing business, and that is a business that his father and his grandfather were in. His approach to the business is different from the previous generation's, but he never really had a typical 9–5 day job either. I grew up with these parents who were definitely unconventional, and it showed me that work is not necessarily 9–5, and that there can potentially be a lifestyle around it.

What is the 'why' behind Cool Hunting?

Part of the 'why' is [that] we are so fortunate today to have a brand and a business that people know. That opens doors that other people might not be able to open. As storytellers, we can get access to stories that not everyone can get access to.

On that level, the 'why' is really helping to inform and inspire our audience with stories that they wouldn't get anywhere else, and helping to create connections within the creative community around the world, and learn more about what everyone is up to.

Whether they're directly in touch with each other, or just indirectly informed through us, it still helps everyone push their craft forward. Being part of the fabric of the creative community is a big motivator for us, and we definitely feel really good about that role.

We also feel really great about giving exposure to young entrepreneurs, designers and inventors who are not yet known. When we can write a story about someone who is just starting out, and that gives them a little more attention – maybe it leads to further stories, maybe they're making something that's for sale and it leads to selling a product – it feels great to be able to help that person further their mission and further their career. Over the years, we've run into many people we have written about who have shared how our story has influenced their journey in launching their career, launching their business, and getting their product out there. That's really satisfying as well.

The other 'why' for us is really about pushing back against the typical business of advertising and of content creation. Yes, we work with advertisers. It's important to work with advertisers, but we also have all these other lines of business so that we're not dependent on advertising. That gives us full control of our editorial, and full freedom to create the content we want to create, and also create the volume of content we want to create.

Being able to have longevity as a media brand that is not following the typical path of an online publication, and being able to show people that there are other ways to approach the business, and still maintain your integrity, and create content that you're proud of is definitely another 'why' for us.

Evan Orensten is your partner in life and business. What advice would you give to small business owners who are looking to work with someone close to them?

Trust your gut. For us, we really knew that we could work together. There was no question. I think there are other couples where it's very clear to them that there's no way they could possibly work together. That's great, too, when you know that. If you're not sure, then I think it requires a little bit of soul searching and a bit of really honest dialogue to figure out if it's going to work. My advice would be, if you're thinking of starting a business with a loved one, don't go into it lightly.

Another piece of advice I'd share came from my mother. Our business is very much based on our lifestyle. Our lifestyle is based around our business. There are really very few boundaries, so it's easy for us to talk about work all the time, whether we're in the office or not. One of the things my mother suggested many years ago that I still feel really good about and makes a whole lot of sense is: don't talk about work at dinner. Have one block of time during the day where you're not talking about work. For us, that means that we might be silent for dinner, or we might talk about fantasy vacations, or we might talk about friends or family. We have to make it a point to not talk about work.

You have run your business for almost two decades. What advice would you give to a small biz owner who is feeling overwhelmed or stressed?

Meditate. Honestly. I think that it is so easy to spin out when you're getting stressed about something, and when you're trying to solve a problem, and there are all these pressures. You have to keep the business going, and maybe you have a couple of employees. You have to make payroll. There's all this pressure hitting you from every angle, which really clouds the ability to make a decision. To take the time to just clear your mind is often grounding, and for me, at least, it helps reveal the answer at times.

I hesitate to say meditate, but it really is the first answer that came to mind. That kind of self-care and that approach to gaining perspective by clearing your mind is really, really valuable, and it's free. Getting that space is important.

What do you want Cool Hunting's legacy to be?

It goes back to your question about the 'why'. There were two answers there that I think really play to what I'd like to see be our legacy.

First, it makes me so happy to hear stories of how our article launched someone's business or launched someone's career. Having that legacy live within that one person makes me really happy. We've got dozens of those people – I don't know, maybe hundreds of them. Having it live within each of those individuals for me is very satisfying.

Then the other piece, which is a broader reaching legacy, would be that we were able to be an online publication that exists in the media world but didn't follow all of the typical trends of online publishing. We were able to maintain our integrity and our approach to content creation by figuring out other types of businesses that wouldn't complicate what we're doing on an editorial front.

coolhunting.com

@coolhunting

Where is your business right now?

PAGES 25–51

I'm showing my age here, but I finished prep (i.e. the first year of primary/elementary school) in 1985. My parents had arrived in Australia from England eighteen months earlier and, not knowing what age kids started school here, I was put into school at four years of age. For the next thirteen years I was always the youngest kid in my year level (often younger than those in the year below me, too).

My son has had a completely different introduction to prep. He was six years old the month he began primary school. He has been the recipient of far more 'play learning' than I was, and – living surrounded by natural bushland – he's been able to enjoy a lot of learning about the environment, climate change and nature's ecosystem. The differences in the way kids are educated now vs. the mid-eighties is massive. And, for the most part, I believe it's far better.

Case in point: I collect my son from school every afternoon around 3.30 pm (#freedom – it's one of the reasons I started my own business).

We always talk about which three things he learned that day. Recently he told me he had spent the entire day focused on one new word. I admit I was initially baffled; six and a half hours on one word? Really?

Me: What's the word then?

My son: Yet.

Me: Yet?? *(Seriously? An entire day on a three-letter word?!)*

My son: Yep, we learned that we can't always know if we are good or bad at something. Instead of saying, 'I can't play basketball' or 'I'm not good at maths' we add the word 'yet' to the end.

He then told me about resilience and trying again, and 'not telling yourself you're not good at something, as you just don't know if in the future you might be'.

One of the most common statements I hear from small business owners I work with is:

'I'm just crap at [insert any area of marketing or business management].'

My reply is always the same: 'How do you know you're crap at XYZ?'

Starting and growing a small business is akin to undertaking a series of intense therapy sessions … with yourself as both the psychologist and the client.

The longer you're running your small business, the more likely you are to be forced to look at who you *really* are, what makes you happy, what leaves you feeling depleted and what impact you most want to have on the world around you.

You will also be forced to look at how skilled – or not – you are at various elements of your business.

If you have staff, you'll find out what sort of manager or leader you are. If you design and sell products, you will discover at what point you're happy to compromise on quality for return on investment. If you sell services, you'll see how far you're willing to go to keep clients happy and, on the flip side, you'll work out how to 'break up' with clients who don't light you up. If you do any sort of marketing, you'll discover how comfortable – or not – you are sharing your story and discussing what it is that your business offers. To run a successful business today, you will need to understand (at some level) things like email marketing, website analytics and SEO.

Running a business guarantees that you will come face-to-face with your fears, as well as any limiting beliefs you may have around money, marketing and mindset. In all cases, you will be discovering things about yourself that you may never have had to think about before. And that, my friend, can be scary.

But it doesn't mean you are necessarily *bad* at any of those things. Often, it just means you are not an expert … 'yet'.

Most of us started our biz with skills in a particular area we felt we could share and make an income from. Those skills may have been in design or making products, in delivering a service or in technology. What we quickly learn is that running a small biz involves a lot more elements than just those we're 'good' at.

But instead of telling ourselves we are crap at XYZ, perhaps we need to take a leaf out of my son's (school) book and add the word 'yet' to our statements.

I'm not good at social media *yet*.

I'm not good at numbers *yet*.

I'm not organised with my systems *yet*.

I'm not good at managing staff *yet*.

Take a minute to ask yourself: what would adding 'yet' do for your mindset?

When we say *I'm not good at X*, it's a finite statement. By simply adding 'yet' to the end of it, we open the door to possibilities about how we can improve.

It may just prompt you to figure out the steps you'll need to take to get from where you are right now to where you'd like to be in three, six, nine or twelve months.

Uncovering your strengths and weaknesses is a journey. You can't expect to get ten out of ten for a skill you've never had to use.

In the previous chapter, you looked at your 'why' and the reasons and beliefs that led you to start your biz. In this chapter, we're going to look at where you are *right now* when it comes to the areas of your business that you'll need to be across in order to succeed. Sure, there will be areas you're not amazing at – *yet!* – but you won't know how to improve unless you know (and are brave enough to acknowledge) where you're starting from.

Most of the following exercises are aimed at people already in business. If you're yet to start your business, answer these in relation to your current role or another role you've had that's closest to the one you will be taking on in your business.

"When we say I'm not good at X, it's a finite statement. By simply adding 'yet' to the end of it, we open the door to possibilities about how we can improve.

What's working?

Let's start with the positive.

Consider the last month in your business. You might want to spend a minute reviewing your calendar, diary or inbox to jog your memory.

 Next, think about the areas of your business that seemed to work effortlessly. Then answer the questions below.

1. Which systems or processes made things easier (for you and/or for your audience)?

2. Which parts of the business were you excited by?

3. What were the projects or tasks that you felt good completing?

4. Were there people inside or outside the business who helped you in some way?

5. Were there books you read or podcasts you listened to that energised you?

6. On the days you felt excited about the business, what was happening?

What's not working?

Get the tissues. This section may trigger an #UglyCry.

 Now that you've had some time to reflect on the good stuff, take a minute to reflect on what wasn't so great about the last month. Then answer the questions below.

1. Which systems or processes (or lack of!) made things harder (for you, and/or for your audience)?

2. Which parts of the business were you annoyed at or frustrated by?

3. What were the projects or tasks that you felt dread about completing?

4. Were there people inside or outside the business who made things more stressful?

5. On the days you felt depleted about business, what was happening?

Learning what to Start, Stop and Keep

Now that we have a better understanding of what's working and what's not, it's time to create a framework for change.

If you have ever worked at a tech start-up or used AGILE, you may have heard of the Stop, Keep, Start framework (also known as Start, Stop, Continue). This is a simple framework that works a little like a traffic light.

Now, I prefer to change the order and call this framework a *Start, Stop, Keep*, as I believe you know deep down what you need to *start* doing and what you need to *stop* doing. The exercise you just completed on what's working vs. what's not working should have helped you understand what to stop and start. For most small business owners, getting these things down on paper isn't hard. It's the *keep* section where things can get a bit blurry.

Start (Green)

Start refers to the things in your business you need to start doing. For example, after completing the exercises on pages 28–29, you may have realised that you need to *start* having a weekly one-on-one with your virtual assistant to iron out any issues during that week, rather than letting things go until your monthly catch-up. Or, you may have realised that your business needs to *start* doing more video marketing as it results in sales, or that you need to *start* documenting processes to avoid confusion and inefficiency.

Stop (Red)

Stop refers to, well, the things you should stop (#HoorayYouWereRight). These are things that are wasting your time, don't bring value to your audience, deplete your energy, aren't making money for the business and/or no longer work with the direction your business is taking. You may choose to *stop* using a particular marketing channel that your audience has moved away from, to *stop* sponsoring an event that provides little to no ROI, to *stop* working with a particular influencer or to *stop* hiring people who don't have experience in XYZ.

Keep (Orange)

Keep refers to the things that are working well for the business and that you already have a good system and/or process for. These may be things like *keeping* email sequences that help you stay connected with new subscribers, *keeping* your awesome hiring process and/or *keeping* a quick ten-minute stand-up meeting with your staff each morning to highlight the day's top priorities.

How do you know what to keep?

Almost a decade ago I worked at Amazon in the UK, heading up the marketing for the entire Kitchen & Home category (literally millions of products). I often joke that you couldn't say 'Hello' at Amazon without having analytics to back up why you were saying it.

While that wasn't entirely true, analytics did play a *huge* role in making decisions for the business. From which emails to send and at what time, through to which words to test in the navigation (e.g. rugs vs. carpets), we referred to the numbers as often as possible.

When you're deciding what to *keep* doing in your own business, there are two important things to consider:

1. What does the data tell you?

2. How does the activity/task make you feel?

Arthur C Nielsen Snr, founder of the market research company ACNielsen, famously said, 'The price of light is less than the cost of darkness'. I completely agree.

If you have areas of your business you're on the fence about keeping, check your data. For example, if you have been spending time building up a collection of videos, look at the data. Are they even being watched? Are people watching all the way through? Are they increasing the time spent on your website (or the platform you're hosting them on)? Are you getting more enquiries when you use them? Are you getting more sales (e.g. if the video is used on a product detail page in an ecommerce store, is there a higher conversion vs. pages without video)? Are they helping build your brand as the go-to for XYZ?

Checking the data helps you look at the facts around things, rather than making a decision based purely on emotion.

That said, the second question to ask yourself is: How does the activity/task make you *feel*?

In the previous chapter, we looked at your 'why': your values, beliefs and the reasons for starting your business. When it comes to your Start, Stop, Keep, there may be things in the business you want to keep even if they are not – yet! – proving fruitful in terms of sales or ROI.

These may be things you just love doing. For example, you may offer one free spot in your workshop or course for someone from a charity or not-for-profit. While this may not help your business financially, it may help you feel more fulfilled and increase brand love.

Deciding what to keep can be difficult. Checking your data, along with your feelings, should make this easier.

Setting your benchmarks

Hands up if you have ever gone for a run. Keep them up if you have ever completed a charity run.

I have completed four 10-kilometre charity runs in the past decade. Each time I've had to train. And each time I started to train, I had to set a benchmark. In the years when I was regularly exercising, I would start off being able to run 6–7 kilometres. In the years when I wasn't as active, that number was far lower. By setting the benchmark, I knew how far I had to go to hit my goal.

When it comes to knowing where you are *right now* in business, it's helpful to set some benchmarks. That is, to know where you are starting from.

You have just spent time reflecting on what your business needs to Start, Stop and Keep doing in order to succeed. Now we're going to look at the actual skills you need to run a small business today, and we'll set your starting benchmark for each one.

> *If you're currently running a business, complete the following exercise with your skills and those of any staff you have working for you.*
> *If you're yet to start your business, complete the exercise based off your own skill set.*

Business can generally be divided into the following five areas:

1. Strategy and business development
2. Operations
3. Human resources (people)
4. Marketing
5. Finance (money)

On a scale of 1–10, where 1 = I don't know anything about it and 10 = I'm an expert, how would you rate yourself in the areas on the following pages? Decide on a rating, then make notes about what you could you do to improve this mark.

Here's an example:

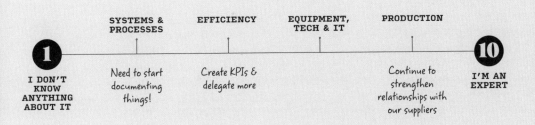

OPERATIONS

SYSTEMS & PROCESSES

EFFICIENCY

EQUIPMENT, TECH & IT

PRODUCTION

1

I DON'T KNOW ANYTHING ABOUT IT

Need to start documenting things!

Create KPIs & delegate more

Continue to strengthen relationships with our suppliers

10

I'M AN EXPERT

When working through these questions it's important not to judge yourself. The point of the exercise is purely to give you a benchmark from which you can improve. You may also realise that in order to take your business to the next level, you'll need to expand or bring more staff on board.

Think of your business journey as being a bit like Google Maps. You need to enter a starting point before you set off.

STRATEGY AND BUSINESS DEVELOPMENT

1. Your business's vision

2. Your business's mission

3. Business development (i.e. commercial partnerships, new markets)

4. Strengths of your business

5. Weaknesses of your business

6. Opportunities for your business

7. Threats to your business

8. The competitor landscape (i.e. the current market)

STRATEGY AND BUSINESS DEVELOPMENT

I DON'T
KNOW
ANYTHING
ABOUT IT

I'M AN
EXPERT

OPERATIONS

1. Systems and processes

2. Efficiency

3. Equipment, tech and IT

4. Production (including manufacturing if you're in a product-based biz)

OPERATIONS

1 I DON'T KNOW ANYTHING ABOUT IT

10 I'M AN EXPERT

HUMAN RESOURCES (PEOPLE)

1. Recruitment

2. Training

3. Succession planning

4. Culture

5. Employee satisfaction

6. Organisation development

HUMAN RESOURCES (PEOPLE)

1 — I DON'T KNOW ANYTHING ABOUT IT

10 — I'M AN EXPERT

MARKETING

1. Branding

2. Social media

3. Website analytics

4. Public relations and media

5. Email marketing

6. Collaborations/partnerships

7. Content marketing

8. Figurehead marketing

MARKETING

1 I DON'T KNOW ANYTHING ABOUT IT

10 I'M AN EXPERT

FINANCE

1. Revenue streams

2. Profitability

3. Investments

4. Tax

FINANCE

**I DON'T
KNOW
ANYTHING
ABOUT IT**

**I'M AN
EXPERT**

Know where you are starting from.

How are you marketing your business?

A key requirement for any business to thrive is good marketing. This is referring to the way you connect with your audiences and guide them through a process of first *knowing* about you, deciding they *like* you and then *trusting* you enough to transact (aka The Know – Like – Trust Principle).

Another way to look at this is by using the Buyer Cycle, which is the journey every customer or client will go on when looking to transact with a business. This cycle is divided into five key stages:

1. **Awareness** Someone at work was wearing earrings that I liked, so I asked which brand they were (now I'm aware of your business).

2. **Research** I then jumped online and had a look at the company's social media profile and website (now I'm conducting research into your business).

3. **Evaluation** I then looked at some other jewellery companies and considered who I might buy from (now I'm in a state of evaluating whether your business is the right one for me).

4. **Purchase** I decided to buy them (now I'm buying from your business).

5. **Post-purchase/Advocacy** I love my new earrings and I can't stop telling people about them. I will definitely buy more! (Now I'm an advocate for your business.)

This is what the Buyer Cycle looks like.

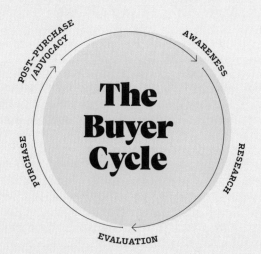

If you have been in business for some time, you may well be aware of this. You may know it by a different name.

I like to use a cycle, as I don't believe the relationship between a customer and a brand ends at the point of sale. In fact, I believe some of the best connections and conversions happen in the Post-purchase/Advocacy stage.

All too often I see small biz owners treat customers like a one-night stand instead of a long-term relationship. *I got the sale, #Byeeeeee!*

Take a few minutes to consider where your business is right now when it comes to connecting with your audience in all stages of the Buyer Cycle.

Do you spend all your time marketing in the Awareness stage, pushing for more and more 'new' customers?

Do you regularly connect with people who have previously purchased from you?

Are you actively using your marketing to guide people through the cycle, particularly in the stages of Evaluation and Purchase?

Is your website, store or physical space set up to allow people to research your business where and when it suits them? Do they know why you started this business?

We will dive into connecting with your audience through marketing in later chapters, but for now, take some time to consider if you are strategically marketing or taking more of an ad-hoc, scattergun approach.

Who identified the Buyer Cycle?

Way back in 1898, the American advertising advocate E St Elmo Lewis came up with the idea of a customer journey when he mapped out the stages a person would take from the moment they were made aware of a brand through to the time they purchased from it. This became known as the AIDA-model (Awareness, Interest, Desire, Action).

Since then the journey has been known by many names, including a purchase funnel, sales cycle, marketing funnel, sales funnel, customer journey and conversion funnel.

Where are you at, right now?

The last thing to consider for this chapter is *you*.

Let me tell you a story. A few years ago a good friend (and fellow biz owner) and I decided to collaborate on a project. We both worked hard on this, but at the end of the project we each felt the other hadn't done what we had expected of them. Being friends, this was a slightly #awks situation, but instead of shoving it under an imaginary carpet, we chose to confront it over breakfast.

As awkward as it was, as we each divulged our opinion on what had happened, we realised just how different we are in terms of the way we approach, analyse and review situations. While we have great respect for one another, we see things differently due to our personalities. My friend was an ENTP, and I at the time was an INFJ (I recently redid the personality test – see opposite – and it's now showing me as an ENFJ). What are these acronyms? They're identifiers of different personality traits that can explain why one person may think an action is completely reasonable, while another thinks it's anything but.

While we may believe that everyone should think like *we* do (after all, it's the 'right way', isn't it!?), the reality is that it takes different strokes to move the world. Our personalities, our values, our education and the way we were raised all have a huge impact on what we expect within a relationship (including a business one).

While it may seem frustrating at times, our differences are actually a good thing. If everyone operated according to the values you believe to be true, or had the same personality type, things would quickly get stale and boring.

My friend and I may have different personality types but, by acknowledging this, we have been able to create a solid partnership that complements each other's traits and leaves us both feeling fulfilled.

Understanding more about myself has allowed me to get rid of areas of my business that were continually bringing me down and amp up the areas that I'm naturally good at and enjoy. It's also made it easier for me to assess whether a biz opportunity works with my particular strengths and interests.

So how do you figure this stuff out so you can really play to your strengths?

First, review the work you have just done on your 'why' and your values. Do they feel rock solid? Do you feel you could stand by them for the next decade (or at least the next twelve months)? If not, review chapter 1 again until you're 100 per cent happy with your selections. If you're happy with your answers, read on …

Personality tests

Spend fifteen minutes taking an online personality test. The personality types mentioned on the opposite page (ENTP, INFJ and ENFJ) are taken from the '16 Personalities Test', which draws its inspiration from Carl Gustav Jung's theory of psychological types, as well as Katharine Cooks-Briggs' co-authored Myers-Briggs Type Indicator. But regardless of which tool you use – each of those listed below are good examples – taking some time to consider your personality type and what you value is crucial for understanding where you are right now in your business.

- 16 Personalities (16personalities.com)

- Creative Types (mycreativetype.com)

- Enneagram (enneagramtest.net)

 Once you have your results, consider the questions below.

1. What surprised you most about your 'type'?

2. After reading through your type's features, what changes might you make to the way you run your business?

3. When you think back over the past year, which parts of your personality may have held your business back?

 If you haven't yet started a biz, consider how aspects of your personality may have prevented you from taking the leap.

Action

Take a few minutes to reflect on where you are *right now* in your business.

Then answer the following questions in as much detail as you can.

1. Consider the things you think you're 'bad' at in your business (or for the business you wish to start). Write these down. What would adding the word 'yet' to those statements do for your mindset?

2. What do you need to Start, Stop and Keep doing in your business? What's working? What's not working? (You can download a free tool to list this at mydailybusinesscoach. com/purpose, or you can simply create a document with four columns, the first for areas of business and the next three for Start, Stop and Keep).

3. On a scale from 1–10, where 1 = I don't know anything about it and 10 = I'm an expert, use the table on the opposite page to give yourself an overall rating in the areas of Strategy, Operations, Human Resources, Marketing and Finance. What do your answers tell you?

BIZ AREA	SUB AREAS	RATING	NOTES
STRATEGY & BUSINESS DEVELOPMENT	1. Your business's vision 2. Your business's mission 3. Business development (e.g., commercial partnerships, new markets) 4. Strengths of your business 5. Weaknesses of your business 6. Opportunities for your business 7. Threats for your business 8. The competitor landscape (i.e. the current market)		
OPERATIONS	1. Systems & processes 2. Efficiency 3. Equipment, tech & IT 4. Production (including manufacturing if you're in a product-based biz)		
HUMAN RESOURCES (PEOPLE)	1. Recruitment 2. Training 3. Succession planning 4. Culture 5. Employee satisfaction 6. Organisation development		
MARKETING	1. Branding 2. Social media 3. Website analytics 4. Public relations and media 5. Email marketing 6. Collaborations/partnerships 7. Content marketing 8. Figurehead marketing		
FINANCE	1. Revenue streams 2. Profitability 3. Investments 4. Tax		

4. Consider the Buyer Cycle and how you are currently marketing your business. Where are you missing out on opportunities to connect with and convert your audience?

5. Consider your personality type. How does it impact where your business is right now? Using the SWOT analysis below, consider mapping out your own strengths (things you're good at), weaknesses (things you could improve on), opportunities (things the marketplace needs that your personality fits well with) and threats (things your competitors may be better at, based on what you know about their personality and/or how they present themselves in their marketing) in relation to your business.

	HELPFUL	HARMFUL
INTERNAL	STRENGTHS	WEAKNESSES
EXTERNAL	OPPORTUNITIES	THREATS

6. Reviewing the activities you have just done, take a moment and write down one or two sentences about where you are *right now* in your business and what you'll need to focus on to get it to the next level. The key here is to be succinct. Remember, you don't want to move into #hustle territory where you're trying to do *everything* and are getting nowhere fast. This is about becoming focused on what you need to do. This is a statement you will come back to as you work through the rest of this book.

You may wish to print out your answer to question 6 and stick in on your desk to ensure you focus on what's most important to your biz right now.

Phoebe Bell, *founder, Sage x Clare*

Phoebe Bell is the founder behind the much-loved Australian homewares and accessories brand, Sage x Clare. Renowned for their bright, bohemian, bold and playful approach to design (including their iconic Nudie Rudie bathmat), Sage x Clare has become a fixture in the design space with their unique, coveted homewares that are handmade and use the best of global artisan creativity.

When and how did Sage x Clare start?

Eight years ago, I was at a crossroads in my life. I'd spent years at university, completing Law/Media and Communications degrees, only to finish with question marks around whether that was really the direction I wanted to go in. I spent time thinking about what it was that I did out of love – not out of obligation – and that led me to begin contemplating a more creative path; one that captured my love for interiors, travel, homewares and fashion. (Rather strange, considering I'd never identified as being creative!)

This led me to taking what I imagined was my dream job (an in-house stylist for a leading fashion brand) but ended up being far from it; I'd never felt more miserable! It was this combination of ruminating frequently on doing something creative, needing to get out of my job before I completely imploded, and a fortuitously timed trip to India that led to the little idea that is now Sage x Clare.

Following this initial idea, and with the full support of my partner, Chris, I quit my job and travelled back to India with the plan to start a homewares brand that celebrated colour, texture and the handmade. The brand was launched a couple of years later in 2013, with little more than a vision and no industry experience.

What was your upbringing like? Did it influence your decision to start a business?

It did, indirectly. Neither of my parents were business owners, but it was watching my mum, specifically, navigate family life and work that had the greatest impact.

Prior to having my sister and I, my mum had good jobs and at times was the breadwinner between my parents. It was only after having children that she took a step back from work, supporting the family and ultimately spending lengthy [periods of] time out of work or taking part-time roles that were flexible with school holidays etc. It was only when my parents eventually divorced in my teens and I witnessed the financial struggle this created, that I began to question the tension women, particularly, face between work and children.

It niggled away at me and even in my early twenties, with a potential career in law ahead of me, I didn't want to be in a position where I would need to choose between the two. It was a compounding factor in starting my business, because I hoped one day I could create a scenario where both family and work life could co-exist without the confines of normal employment. Of course, running a business has its own set of challenges, but there is a level of flow to my work life and family life, which I enjoy.

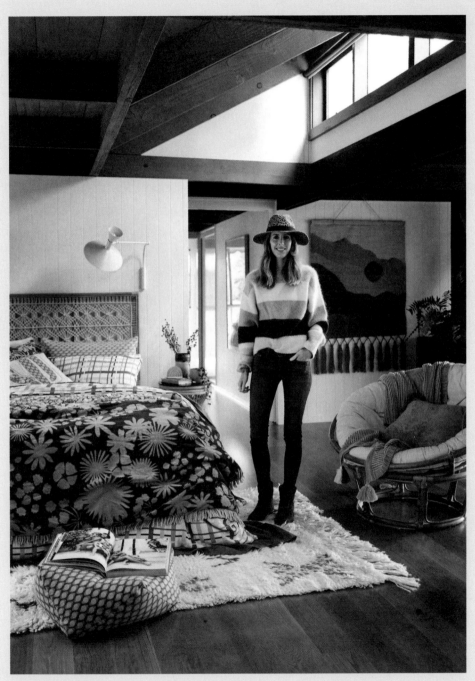

Photo © Armelle Habib

What is the 'why' behind your business?

The 'why' in its essence is to create moments of joy and happiness in people's lives. I'm an extremely visual person, so aesthetics are important to me. I can be moved by a beautiful room, an object, a landscape – it kind of gives me a breathless, giddy feeling when it happens. It's particularly present when there is colour, texture and an intrinsic handcrafted feel to something. Sage x Clare is really about creating that for others. Aesthetics can often be considered superficial or unimportant, but I disagree. Environments and what we put in them can have great impact on the way we live and how we feel.

You spend a lot of time in India for the business. What has that been like?

India has a special place in my heart. The feeling of possibility there is extraordinary, and I owe so much of my best twists and turns to this place. It's an incredible place. The artisanal skill there is vast – you can conjure up your wildest dreams in terms of design and there will be an artisan willing to try it. It's far less rigid than producing in China, for instance, where it often comes down to meeting high minimum order quantities and/or being production friendly.

Of course, navigating business in any foreign country is fraught with risk and India is no exception. I knew nobody in India, nor had any leads when I first started Sage x Clare, so I spent months there navigating my way through possible suppliers, having only my gut instinct to guide me. It was also challenging being a foreign woman with no 'real' business behind me; I'd often sit in meetings in India and have my husband dial in from Australia to circumvent some of the gender inequalities that exist there.

And then there's the difference in business customs and culture, which is like chalk and cheese with Australia! I've learned to both accept and embrace this as the years have gone on and understand that, when doing business in India, the goal posts are always shifting.

What advice would you give to other small biz owners looking to produce overseas?

There is a lot to consider when manufacturing overseas and I'm still learning the ropes eight years in!

First, it's imperative to actually visit manufacturers you're intending to use (don't always give them a heads up that you're coming). Everything can look good on paper, but until you've been there, spoken with them and observed their operation, you can't really know if they're a supplier you'd like to do business with.

Second, have someone on the ground. In the early days, that person was me. I would spend months at a time in India so I was present throughout the sampling, production and quality control phase. As soon as I left, it became very difficult to maintain regular communication and to have proper visibility of what was really happening. Once long trips to India became harder to do, I engaged an agent with experience in textiles, suppliers and local practices to take over and advocate on my behalf. We now have a team that regularly visits our suppliers and project manages the entire manufacturing process from sampling through to export.

Third, trust your instincts. So much of my business has been built on gut feel, particularly in the beginning. If a supplier is feeling off, then pay attention and listen.

Social media is a major marketing avenue for you. How has this helped your business?

Social media is critical to Sage x Clare and has allowed the brand to grow without needing to engage expensive media agencies or campaigns, which I am incredibly thankful for. As much as we all like to whinge about social media, it really is a gift to small business and goes some way to levelling out the playing field against established brands with deeper pockets. It's allowed me to talk directly to customers, to really establish what the brand does and, more broadly, what makes it tick.

There is of course a not-so-great side to social media and, for me, this is the mob-like behaviour that can exist. My business is far from perfect, we make mistakes and therefore open ourselves up to criticism. Usually we are met with fairness and, more often than not, compassion, but there have been times where hysteria sets in and it's left me feeling vulnerable and exposed. For instance, a goodwill gesture to support a breast cancer charity went sour when the graphic I'd been asked to share inadvertently offended some breast cancer survivors.

It's a careful balance to show personality and stand for something, without inadvertently inviting a wave of negative attention.

You're the face of the business. What advice do you have for biz owners who know they need to get themselves 'out there' but find it daunting?

Being the face was far from the plan but, thanks to the first couple of years really only being me, it evolved that way. I started almost pretending that Sage x Clare was bigger than it was – I'd use words like 'we' when talking about the brand publicly because I was embarrassed that, in truth, it was just little old me, working from home with frankly no idea what I was doing!

Then, over time, I started to realise that this is a niche brand with a really good 'humble beginnings' story – that there is great value in telling that story and in having a personal voice that might resonate with others and ultimately build connection and community.

Changing my strategy was certainly daunting at the start – even finding my voice and then fussing over how it might come across. But eventually I came to realise that I'd always prefer to say something, create something, have my hat in the ring than stand for nothing at all. To others finding this challenging, let this be the driving force that encourages you.

Which two areas of business have been the biggest learning curves for you? How did you overcome these?

In the beginning I was all things to the business. Without me, it didn't run and, while that can work for a period of time, it's not exactly sustainable.

It's only been in recent times, where my body and health issues have forced me to change, have I begun working towards a business that doesn't 'need' me all of the time. Overcoming this has been a two-step approach. First, I've had to take a really hard look at myself and own the things I'm good at and delegate the rest. Second, I've had to restructure my team and empower those I work with to make decisions, particularly when I'm not around.

The second biggest lesson I've learned is to build an armoury that keeps me, at my core, protected. I used to ride every little bump or win with full force – if a shipment was late, I'd think the world was going to end. If a customer complained, I'd sometimes cry. Eventually, the emotional rollercoaster of it all became too exhausting and my moods directly correlated with how Sage x Clare was doing – not ideal! With time, I learned to let it wash over me rather than feel it right within me. It was a conscious mindset change to create this separation. Of course, I still have good days and bad days, but it seldom causes me anywhere near the volatility it used to.

What do you want Sage x Clare's legacy to be?

In keeping with our 'why', it would be to provide moments of joy, colour, texture and workmanship to people for many years to come. I would love for that to be Sage x Clare's gift to the world.

sageandclare.com

 @sageandclare

Who do you serve?

PAGES 53–73

It's funny, the older you get the more you need people in your life who get you. About a year ago I decided that I needed to meet more women in my area. As I mentioned earlier, one of my beliefs about life is that nature can heal and revive. It's why my husband and I have chosen to live in a bushy suburb about 25 kilometres from the city of Melbourne. Unfortunately, most of our good friends don't live anywhere nearby.

In addition to helping small business owners grow and scale their business, I have also been a published writer for the last nineteen years, contributing to numerous publications. This has allowed me to meet – and interview – some pretty interesting people, most of whom also happen to be small business owners.

So, when I thought about meeting women who lived locally to me, I initially drew on people I had interviewed who also lived in the area. I then added to that list women I knew from my son's primary school, and then one or two good friends who lived nearby. I messaged them all about forming a book club and, fortunately for me, they all agreed, some adding friends of their own to the group.

On the night of our first meeting, I was a little nervous. There's something first-day-of-school-like about meeting potential new friends. During the introductions, each woman spoke about her life, her career and why she had wanted to join the book club. Within minutes we were all crying with laughter as we heard story after story about juggling motherhood and business, or being a stay-at-home mum, and all that such adventures entail.

You could feel the energy in the room. We were all smiling because what each woman was saying was so true to our own lives. It was as if every woman in the group thought, 'Yeah, these women get me.'

When it comes to receiving reviews, testimonials or other comments from your clients and customers, it doesn't get much better for a small biz owner than hearing, 'Yeah, this brand gets me.'

In this chapter, we're going to shift the focus from you, the small business owner, to the people whose lives are improved by what your small business offers.

Understanding your audience isn't simply a matter of pulling together a buyer persona, adding some demographics and ticking that box off your Business Planning 101 Checklist. It's about knowing what you're offering them, uncovering who they are as 'real' people and communicating with them in a way that truly connects.

We have already spent some time focusing on things like your 'why', where you're at right now and the practical changes you may need to make (i.e. your Start, Stop, Keep) to grow your business. As we dive into who your audience is, you will further uncover how they connect with your 'why' and how you might deepen the relationship they have with your business by tweaking things that matter most to them (e.g. customer service processes, marketing channels, price points).

Pour yourself a tea (or your beverage of choice). This is one of the most important sections of this book. Brand loyalty is ultimately gained by building real relationships with people, and that all starts by understanding how you can help your audience.

What does your customer need?

Do you know who your audience is?

Who are the people that most benefit from the products and/or services your business offers?

Most business owners will have done some work on their audience – usually in the form of a Buyer Persona or Ideal Customer Avatar. These will ask you to consider things about your audience such as their age, their name (e.g. is she a Kati or Katherine?), how much they earn and where they live.

The thing is, these are just things on paper. They don't actually tell you much about the person. For instance, I'm thirty-nine, university educated, a mother of two boys, I've been married for eleven years and I live in Melbourne. You could have another person who identifies as a woman with exactly the same 'traits', but we may be polar opposites when it comes to the what, why and how of spending our money.

One of the nicest emails I've ever received about my business was from a woman who attended one of my live marketing workshops. Almost a year later, she emailed me to tell me how the workshop had changed her business and, in turn, her life.

With her permission, I'm sharing it with you:

Dear Fiona,

I wanted to write and let you know that I did your Marketing for Your Small Business course last year. I took so many tools out of it that we are using (including budgeting and Excel spreadsheets!!! Who woulda thought?).

But the BIGGEST thing you gave me was the calendar that said – Your Awesome Year. On that very day while we were there in your workshop, I wrote in the box for August: Take the kids to Vietnam.

Now, we have five kids and we both work six days in our business, so these ideas sometimes seem unattainable – but I eventually told my husband that that's what we were going to work towards.

So, we set out our budgets (business and personal) and the universe was very supportive; we got brilliantly cheap flights, our bank manager dropped our interest rate and we got tax back to pay for school fees and airfares.

And we have to work to make work work while we're not here for twelve days – so I'm writing procedures and finding casual staff, and my husband's filing recipes in the right place (he's even listening to your suggested Seth Godin podcasts) ...

... and now we feel like we can **do** stuff.

So now I'm thinking about pulling cupboards out of my kitchen and growing a creeper over my shed and planting lots of garlic and all those other little things that are their own reward.

I am very grateful to have signed up to this weekly email and to have attended your workshop – you really are one very generous person.

I can't really thank you enough – but thank you – and one day when you have time, please join us in our cooking school as a little thank you for your generosity in helping our small business.

That email is not only something that makes me feel good and reminds me of why I started my business, but it also highlights the problems faced by so many small biz owners (aka my audience).

These problems include:

- Feeling there's not enough time to do the things they *really* want to do.

- Lacking a sense of clear goals.

- Lacking a road map for achieving their goals.

- Lacking the systems and processes to make goals happen.

- Feeling they have to sacrifice family time to make the business 'work'.

- Feeling like they are the only ones who can run the business.

When it comes to knowing who you serve, the first step is to know what problem your business solves.

Think about your ideal audience, then consider:

- What is currently not working for them?

- What are the frustrations they encounter on a daily basis?

- What do they complain about?

- What do they want to reduce or remove from their life?

- What is their biggest problem?

For some of you, the problems your audience faces will be obvious. For others, they may be harder to define (this will be especially true if you are yet to launch your business).

In both cases, it helps to conduct further research.

Validate your assumptions

How often have you had an idea for a new product or service in your business? How often have you validated those ideas by running them past real people?

If you're like most small biz owners, the answer to the first question will be 'thousands of times' and the answer to the second will be 'not often'.

We can easily get into a small biz brand bubble, where we believe we know the problems and frustrations facing our audience. But if we don't validate these, we can spend money and time creating a solution to a problem our audience doesn't actually care that much about.

When it comes to understanding the problems your audience faces, it pays to validate your assumptions.

HOW TO VALIDATE YOUR ASSUMPTIONS

There are many ways to validate your assumptions. Some of the most common include:

- Polling your audience on social media.

- Sending a survey email.

- Creating an online focus group.

- Conducting phone interviews.

- Asking questions in Facebook groups.

- Looking at Google Trend for changes in search result inquiries.

- Reading lower than three-star reviews on similar/competitor products and services online (Amazon, Quora, Google My Business).

- Using the search tool inside closed Facebook groups to find real-life questions about your product/service (e.g. 'Why can't I ...?', 'I wish I could ...', 'Has anyone used ...?').

- Checking the hashtags #BadCustomerService, #BrandFail, #GoodBrand and #ProductLove on Instagram.

ASKING THE RIGHT QUESTIONS

Your validation questions will differ depending on your particular business offering, but in all cases they should include The Five Ws (think the types of questions a journalist would ask):

- **Who** Who are you and how does this (industry/product/service) relate to your life?

- **What** What do/don't you like in regards to (industry/product/service)?

- **When** When do you most need or use this (industry/product/service)?

- **Where** Where would you look to purchase or learn about this (industry/product/service)?

- **Why** Why does this (industry/product/service) matter to you?

Taking time to validate your assumptions will not only show you what problems and frustrations your audience is facing, but also how you can become their most desired solution.

Are you the solution your customer needs?

Think about the last product you bought. Given that very little is original these days (#TruthHurts), consider the competitor brand to the one you chose. Now, think about why you chose the one you did.

Chances are you considered it to be superior in some way. The price may have been cheaper, or perhaps it would arrive sooner than another brand's products. It may have been more accessible to you (e.g. in a shop near your house vs. online), the brand may have fantastic customer service, you may have purchased from them before and therefore trust them or it might have been the brand a friend recommended.

When it comes to understanding who you serve, you need to know how your business is *better*.

Consider five competitors to your business (or the business you hope to launch). Before you sigh and tell me you have no competitors, swallow your ego and accept that you do.

How does your business do things better? Are you regularly showcasing this to your audience?

It may be at this stage that you realise your business doesn't do things differently, or even better. If this is the case, take some time to again go through your 'why', your values and your beliefs. How might you integrate these, along with what you know about your audience, to tweak your offerings, your customer service and/or your communications?

Ask past clients and customers for reasons they chose to work with or buy from you. Then, think about what 1 per cent better would look like. What would 10 per cent better look like? Perhaps it's giving more context on your product detail pages, or direct messaging voicemails on Instagram rather than an automated email when people purchase.

Which small things could you tweak in your business to make it better for the people who need it? Rather than feel deflated by this exercise, use this knowledge to tweak and test, then build a better business. Remember, nothing changes if nothing changes.

Who most needs what you're offering?

Now that you know the problems your audience faces and that your business can offer a (better) solution, it's time to look at who most needs what you're offering, aka your ideal audience (IA).

How can you ensure your brand is a part of someone's life? Working this out starts with getting clear on your niche.

Imagine for a moment that you sell sleep education courses for parents. You may initially consider your audience to be any parent.

But this, my friend, is way too broad. How many parents do you know? Multiply that by a million. If you're talking to all of them, you're not connecting with any of them.

One way to start the process of niche-ing down is to ask: WHO needs what I offer *most*? It's that last word that will enable you to really gain clarity on your audience.

Let's go back to the sleep education course provider. Who most needs this – the parent of three children, of whom the youngest is three months, or the parent of one three-month-old child.

As a parent of two, I can tell you that I would have emptied my bank account in the first few months of my eldest son's life to understand *why* he was crying (#AlllllllNight) and how I could stop it. When my second son came along six years later, I had a much better understanding of how to react to his cries, what the issue might be (fatigue, food, farting) and how I could solve it.

> *Are you thinking out of fear? Flip the script. What's the best that could happen?*

Who needs what you offer *most*? Can you narrow that down? Is it a two-parent household or a sole-parent household with a three-month-old?

Now, this is an assumption, and I sincerely hope I don't offend anyone (I've validated it with sole parents), but you may deduce that a sole parent may want more help getting their child to sleep than a household in which there is the possibility of an extra adult to help.

So, you may decide to first market your business to an audience made up of sole parents with a three-month-old.

Niching down allows you to tailor your marketing to people who most need it, to speak to the problems and frustrations *they* face and connect with them by offering a solution that seems tailor-made (e.g. 'Every other program assumes I'm in a two-parent household. This program is different, I feel like they get me').

Consider the ideal audience you currently market to. Could you niche down? What would this look like?

Why does it scare you? (Let's get real, most small biz owners are scared by this, because they've bought into the myth that bigger always = better. It doesn't.)

Are you thinking out of fear?

Flip the script. What's the best that could happen?

REMEMBER THEY'RE REAL PEOPLE

Years ago, I was running a workshop for a high-end appliances company. They were discussing the results of a focus group they had held for a new collection. The results suggested that the ideal audience was stay-at-home mums.

Eager to deliver content that spoke to these women, the company came up with a series of campaigns aimed at 'mums' – i.e. parenting articles, reviews of domestic appliances, recipes to try. While hashing out these ideas, it came to light that despite these women, on paper, not technically being in *paid* work, they thought of themselves as businesswomen. They looked after the household staff (cleaners, gardeners, tutors), they handled the family's rental properties, they booked their family holidays and they volunteered at various organisations. They didn't want to be pigeon-holed into one category, when the way they thought about themselves was entirely different.

The problem with many Buyer Persona or Ideal Customer Avatar exercises – and if you've been in business for a while you'll have no doubt done many of these – is that they diminish people to demographics only. Example: Sinead is thirty-eight, she has three kids, she lives in this suburb and her annual income is X. Charmaine is thirty-eight, she has three kids, she lives in the same suburb as Sinead and her annual income is similar. But … they are completely different people! The way they shop, their values and beliefs about the world, the way they raise their children – ALL different.

To truly serve your audience, you have to look not only at who they are on paper, but who they aspire to *become*.

What do they value? What impact do they want to have on the world? How might engaging with your business help them do that?

THREE THINGS TO MAKE THEM REAL

Once you have done some research into your niche and validated any assumptions you may have, it's far easier to build a 'real' profile of your audience.

How do you do this?

1. By asking #AllTheThings.

2. By visualising them as real people.

3. By speaking their language.

1. ASK #ALLTHETHINGS

Too often we limit the questions we ask when creating our IA. In addition to the stock standard questions (marital status, location, salary, name, age, values, fears), we need to ask questions that create a much more 'human' and relatable profile, rather than just an 'on paper' persona.

Being able to sidestep the #hustle and build a business you love is, in part, about understanding who you most want to serve through your business and how you can create an authentic, genuine relationship with those people. You want to be able to think of them as real people, not just demographics on a Keynote presentation.

 Questions to prompt your new audience profile might include:

- What's their 'feels-like' age? How old do they 'feel' most of the time?

- What's the one Netflix show they love, but would never admit to watching?

- When was the last time they cried?

- What do they most desire in life?

- What's their #1 party song? You know, the one that compels them to get on the dance floor, no matter what. (One of mine? 'Paper planes' by MIA #AllIWannaDoIs)

- What does their dream home look like?

- What do they feel guilty about?

- What song do they belt out in the shower/car?

- Which values guide their life?

- What keeps them awake at night?

- What type of books are they reading?

- What do they believe in?

- Where would they be at 8 am on a Tuesday?

- Do they find toilet humour funny or foul?

- Which podcasts do they listen to?

- If money was no object, which brands would they buy from?

- If they were offered sex with their partner or a night in a hotel alone, which would they choose?

Most of us would be able to answer these questions about our friends, yet we struggle to answer them for our ideal audience. If we can begin to think of our ideal audience as friends, we have a much better chance of connecting with them and building genuine brand loyalty.

Consider your ideal customer or client. Could you answer the above questions about them? Would this help you make them into a real person?

2. VISUALISE THEM AS REAL PEOPLE

The next step is to visualise these people. Pinterest is my go-to tool for doing this. You can add a secret board, 'My Ideal Audience', then split this into the following categories:

- Words or mottos they live by.

- Celebrities they admire.

- Netflix shows they watch.

- Podcasts they listen to.

- Styles they lust after.

- Houses they dream about.

- Movies that impacted them.

Or any other categories you think suitable.

To make this step easier, I've created some example Ideal Audience mood boards on my Pinterest account (pinterest.com.au/mydailybizcoach). Feel free to duplicate these or start your own from scratch.

The purpose of these mood boards is to help you visualise your audience as real people, not just demographics on paper. Having this information may also help in your marketing – which podcast to pitch to (i.e. the ones your audience listens to!), how to style yourself for keynote presentations or brand photoshoots, books you can use to create quotes for social media or in your emails, or even which celebrities you might discuss in your next blog article (e.g. 'Get Gwyneth's Hamptons home style on a budget') .

Visualising your audience using mood boards can also quickly help your contractors, virtual staff or any freelancers understand – at a glance – who you're trying to connect with.

3. SPEAK THEIR LANGUAGE

If I asked you to tell me which 1990s film this next line is from, could you?

'She is toe-up. Our stock would plummet!'

Any idea?

Clueless.

Not you – that's the name of the film!

Yes, *Clueless* – the film that rocked my world in 1995 and had me and my besties quoting it for the next two years. (Okay, let's face it, we still quote it to each other today, #tragic #MaybeNot.)

Have you ever considered the films that impacted your ideal target audience/client/customer? Or even the catchphrases or TV themes they grew up with and could recite within seconds.

The final step in making your audience 'real' is to consider how they speak, and the language they would most connect with.

Now, I don't know about you, but I will speak differently to my seven-year-old son than I will to my eighty-three-year-old father. I may be friendly, outgoing and compassionate to both, but the words I choose, my intonation and the way I convey concepts will all differ.

The same can be said for your audience. Are they looking for a serious, formal tone or do they want you to be light and conversational? Do they use slang or acronyms or do they use the 'Queen's English'? Do they want to be entertained by your marketing and content, or do they want to feel supported by someone with serious authority in a certain industry?

How are you speaking to your audience right now?

Quickly review the last eighteen posts on your business Instagram or the last five on your LinkedIn profile, your status/update emails from an ecommerce store or the last pitch deck you sent a client. Does that language really reflect *their* needs and the way you want your brand to be perceived?

One of the most common mistakes I see small biz owners make is a tendency to either make everything formal in online copy or social media posts, or to be so vanilla it's fatigue-inducing. As a result, language feels stifled, safe and robotic.

Does your language suit your audience or do you need to make some changes?

WHERE IS YOUR AUDIENCE IN THE BUYER CYCLE?

Back in the mid-1990s, I discovered a little band called The Clash on a late-night radio show. I was fourteen at the time and had never heard of them, so when I walked into a record store a month or so later, I thought nothing of saying, 'I'm looking for this new band, you may not have heard of them. They're called The Clash. Do you have any of their music?'. To this day I don't know how the guy kept a straight face.

With every business, there will be people who are die-hard fans and there will be people who don't yet know they exist, and then a bunch of other people in between. Remember the Buyer Cycle and the five stages people will move through when looking to interact with your business?

1. **Awareness** Someone tells you about a new restaurant.

2. **Research** You jump online to see what you can find out.

3. **Evaluation** You decide if you think this restaurant is worth going to instead of somewhere more familiar.

4. **Purchase** You decide to go there to eat.

5. **Post-purchase/Advocacy** You have such a great time, you tell everyone you know to check it out.

When thinking about your audience, also think about where they are in the Buyer Cycle and how you might communicate and connect with them depending on where they sit. What changes might you make to your communication with your audience based on the five different stages of the Buyer Cycle?

Could you engage with people who have purchased from you previously?

Could you increase transition from the Evaluation to the Purchase stage by providing more information about your products and services (in particular, the benefits of them, not just their features)?

How can you use the Buyer Cycle to genuinely connect with your audience, build a community around your business and convert people into your biggest advocates?

How can you use the Buyer Cycle to genuinely connect with your audience?

Embracing the evolution

I've been a Beyoncé fan since the late 1990s, when my friends and I were convinced that 'Say my name' was based on our personal dating experiences. As Beyoncé has evolved, so too has her audience, many of whom are now mothers with young children, dealing with the same challenges as Bey (though rarely the same resources).

As you consider your audience, understand that nothing is set in concrete. They, like anyone, will evolve and change over time. Perhaps your brand will only be part of their life for a short period (e.g. sleep education for newborns), or perhaps it is one they will have in their life for decades (e.g. large appliances).

How can you create the best possible experience for them?

How can you use what you have discovered in this chapter to truly connect with them?

What will you test this week, this month, this quarter when it comes to audience connection and engagement?

How will you speak to their beliefs, their fears and their desires?

How does your 'why' impact your audience?

Warby Parker, an eyewear brand based in the US, has been able to build a company valued at more than $1 billion in less than a decade. Part of this is due to their super strong 'why', which is all about giving back to those less fortunate. The company does this by giving a pair of glasses to someone in need for each pair bought (to date, the company says they have provided more than one million pairs), providing eye care in the developing world and maintaining a net zero carbon footprint. All of these actions align to their why (which they share across all of their marketing channels). Given their success as a brand, one could assume that these actions also speak to the values and beliefs of their ever expanding audience.

Action

Take a few minutes to reflect on the ideal audience you want to attract, engage and retain in your business.

 Then answer the following questions in as much detail as you can.

1. What is your audience's problem with regard to your product, service or industry?

2. How will you validate these assumptions?

3. How can you become their most desired solution?

4. What do you do better than any other business in your industry?

5. Can you niche down? What scares you about this?

6. Which additional questions can you answer about your audience to make them more real?

7. Which mood boards will you create for your audience and by when?

8. What language do they use? How will you include this in your communications?

9. What will you test this week, this month and this quarter when it comes to audience connection and engagement?

10. How will you speak to their beliefs, their fears and their desires?

Fatuma and Laurinda Ndenzako,
founders, Collective Closets

Fatuma and Laurinda Ndenzako are sisters and co-founders of apparel and accessories brand Collective Closets. The brand was born after they took a family trip to their native Kenya and were struck with the idea of combining traditional African patterns and fabrics with contemporary Melbourne design. Creative Closets partners with Mission of Hope on a series of initiatives that takes a portion of proceeds from every Collective Closets sale to help children in Africa.

What is Collective Closets? What was the catalyst for it starting?

Laurinda and I started Collective Closets almost five years ago, after returning from a life-changing trip to Kenya. We both remember landing in Nairobi for the first time. From the minute you land, the city sweeps you away, takes your breath and engulfs you in a journey of an eclectic, colourful and culturally enriched world. The trip reminded us about our love of fashion and the way it has bonded us throughout our lives.

We genuinely gasped when we first saw people wearing the Maasai shuka check, a fabric that has since become our signature. It was just so beautiful. We knew straightaway that this was a look we wanted to wear every day. We wanted our label to reflect our love for Africa and specifically the Maasai tribe.

Laurinda and I grew up in a family that sewed and created. We had always dreamed about working in fashion but never knew quite where we would fit in that world.

We did know we had a point of difference in terms of style, and over time this was something we became known for. Now, Collective Closets is an extension of who we are and a celebration of our culture.

It has been such a joy to introduce our audience to African culture – not as a tokenism but as a celebration.

What is the 'why' behind the business? How do your beliefs about the world impact your business?

The 'why' behind our business is both our fabric and our narrative. The colours of African fabrics are bold, made for women who want to stand out and own their individuality.

Our customers trust us to bring out their best and, in turn, we make every campaign a celebration of being a woman. We want to talk to our customers, we want to have interesting conversations with them about things that matter to them. We want to empower them to feel great in their own skin no matter what shape or size they are. We want our customers to feel welcome and appreciated in our space, like they are part of our tribe.

What was your upbringing like? How did it influence your decision to create Collective Closets?

We were lucky to have a beautiful childhood filled with love, imagination and possibilities. Our parents instilled in us a belief that all possibilities are achievable and we should

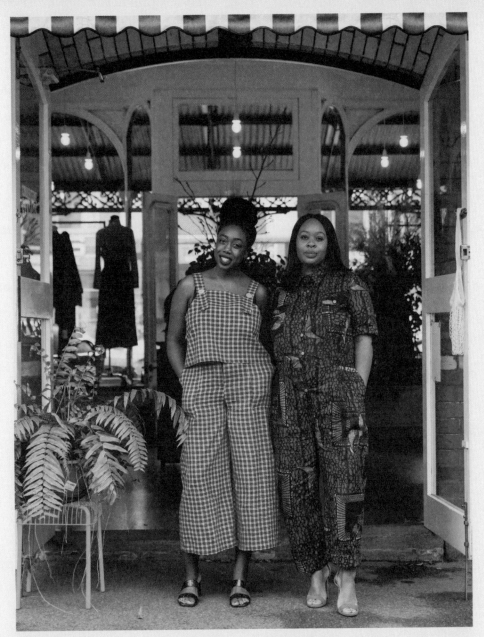

Photo © Michaela Barca

It has been such a joy to introduce our audience to African culture – not as a tokenism but as a celebration.

reach for the stars. On a practical level we were always supported – or should I say strongly encouraged – to be university educated while keeping a side project.

We grew up in a family that loved fashion and clothing. We were encouraged to express ourselves through dress. Our parents celebrated our culture through dress; it was magical! We would love to watch our mother as she dressed in gorgeous fabrics and stunning colours. It made us proud to be African and helped us to understand our culture on a deeper level when some of the narratives around us weren't so positive.

Beginning life with this admiration of style and the celebration of its power, it seemed natural for us to want to start Collective Closets.

Collective Closets is a brand that gives back. How did you choose which cause to support, and what advice would you have for other small biz owners who may want to add an element of giving back into their business?

There is a higher level of consumer consciousness now and, happily, an intrinsic part of a modern business model is using your brand power to give back.

Personally, I would urge business owners to choose a cause that makes sense for their brand and reflects their overarching ethos.

Mission of Hope was perfect for Collective Closets. The label's roots are in Kenya, which is the source of our inspiration, materials and a portion of our production. Critically though, we're passionate about fighting for gender equality, female empowerment and the right to education. Mission of Hope aligns with this.

What has been the hardest obstacle you have had to overcome as a small business owner, and how have you done so?

Trying to grow our business while managing cash flow has been a challenge. We have so many ideas and campaigns we would love to action, but we don't always have the budget to roll them out. We always have to ask ourselves, 'Is this something our customers would want? Or is it something that we just want to do?'

Staying in our own lane is another challenge we face: trying not to compare what other brands are doing vs. what we are doing. Trying to just do things that we are truly passionate about (staying true to our ethos), even though every other brand might be doing it. Remembering we are a unique brand, and customers are coming to us for a point of difference. And that difference is power.

Managing our time is probably our biggest challenge. Laurinda and I are both mothers. Trying to run a business while wrangling a two-year-old and a three-month-old is crazy! We now try to set strict, but realistic, deadlines that we can definitely meet. We have also had to grow our team and empower them to make decisions that we normally would. Building a strong, amazing team has really been key to keeping us afloat during these hectic times.

You are sisters, as well as business partners. What advice would you give to someone looking to do something similar, i.e. work with a spouse, sibling or close friend?

Ensure you have clear roles that play to each other's strengths, then outsource the skills you don't have. This will help to prevent unnecessary fights and will bring out your best. Know that you are going to make tons of mistakes! And that's fine.

Do you have any mantras or quotes that you come back to, again and again?

Absolutely yes, there are so many! 'Stay in your own lane', 'Kindness is key', 'Treat everyone like they are coming into your home', 'Always stay true to yourself' and 'Be the best you can be'.

Laurinda and I are always going back to these mantras because they keep us going and keep us sane. We're trying to build an enduring legacy brand, so on tough days

we relay these sentiments to our team and ourselves.

What do you want Collective Closets' legacy to be?

We want to be a brand that has helped change the way customers buy clothes. Our aim is to encourage customers to want to know where their clothes come from and who is making them. While we want to be known for gorgeous fabrics, classic silhouettes and remarkable customer service, ultimately we hope to change the narrative around how women perceive their bodies.

collectivecloset.com.au

🔘 @collectivecloset

Photo © Michaela Barca

CHAPTER

04

What are you saying?

PAGES 75–95

Between 2004 and 2007 I worked as the editor for three lifestyle magazines. One was about fashion and, consequently, in January 2006 I was sent along to one of the biggest Australian music festivals at the time, the Big Day Out, to take photographs of 'festival style' for our 'How to Wear' pages.

I arrived at the festival mid morning and met up with my friends from work, noting that there was an extra face – a friend of a friend – in our group. He was a little taller than me, decked out in grey jeans and a soft faded red T-shirt. His face was liberally sprinkled with freckles and his skin tone was a perfect tan (aka #TotalBabe). As the day progressed I learned more about this quietly spoken man. He had studied Fine Arts (Painting), he liked music, his parents were Anglo-Indian – though he had never been to India – he played guitar in a band, he worked as a graphic designer for a toy company, and he was planning a long holiday across Europe and Japan later in the year.

I was mesmerised, and took to following him from stage to stage, bar to bar. In return he seemed to walk further away from me. As the night progressed, I decided enough was enough. If he wasn't picking up on my signals, then screw him. I had seen MIA live, spent a day in the sun with friends and entered the festival on a free ticket. All in all, it had been a good day. If it didn't end with this guy asking me out, that was fine.

Completely. Fine.

Nine months later, at my best friend's birthday party, I met this guy for the second time. We chatted for hours and ended up, at 4 am, kissing on the dance floor. That was 29 September 2006.

Two years and two months later we got married.

The person I met back in January 2006 has grown into an incredible husband, partner, friend, and father to our two sons. In short, he lives up to every lyric in Salt-N-Pepa's 'Whatta man'.

Despite the way my husband has evolved as a person, there are still elements of his personality and his style now that were evident that first time we met. The things he values in life, the way he presents himself, the beliefs he has … most of those haven't changed at all.

Why am I sharing all of this?

Because when it comes to building a business you love, your brand plays a leading role. Your brand can be the difference between someone thinking you're cute and following you for a day (e.g. music festival stalker) to someone thinking you 'get them' and wanting a lifelong relationship (oh hai, married mama of two).

Brand loyalty is built when your customers (past, present and potential) feel aligned to your values, your style, to the story behind your business (aka your *why*). The journey from brand awareness to brand advocacy takes place when people feel a genuine connection with what it is that you're offering; they know that having your brand in their life improves it.

In this chapter, we're going to explore what your brand says about you, what your brand is the go-to for, the reasons people choose to buy from you, both emotional and rational, why looking good is important, and how you can use your brand and marketing to *connect* with your audience, *cultivate* a community and *convert* people from nonchalant browsers into passionate brand advocates.

If you already run a business, this chapter will remind you to get crystal clear on what it is you're saying and how you're saying it. If you're yet to start your business, this chapter will be one of the most important as you create the foundations your business will be built on.

What is a brand?

This may seem like Business 101 – I can almost hear you screaming #ReclaimingMyTime – but before you get all bent up, hear me out. I have worked with owners from hundreds of businesses across the globe, but not all of those business were *brands*.

There's a myth in the business world that a brand is simply a logo, a colour palette, a few templates and a tagline. This is where so many businesses (large as well as small) get it wrong.

Your visual identity is just *one* part of your overall brand. It is not your brand.

So, what *is* a brand?

While the idea of 'branding' is said to have begun in ancient Egypt when they literally *branded* animals to show who they belonged to, it's evolved a bit since then.

A brand is made up of five key elements (see opposite). Consider these elements of your business (or the biz you hope to start). When you worked on defining your 'brand', did you limit it to simply a logo, colour palette and fonts, or did you consider your brand in its entirety?

Unfortunately, many small biz owners (and even big biz owners) make the mistake of pouring money and time into a visual brand identity without spending the same amount of time on other – just as important – brand elements. Just because you have a logo, doesn't mean you have a brand.

The five key elements of a brand

1. **Mission, vision and values** What is your purpose, where is the business going and why does the business exist?

2. **Perception, personality and positioning** How is the brand perceived in the marketplace and how is it positioned to attract and engage its ideal audience (i.e. is it mass market or niche? Exclusive or mainstream?) If it were a person, who would it be and why?

3. **Culture and people** How do its people shape the company? What sort of culture does it cultivate? Who is it aiming to attract? Who does it aim to repel?

4. **Identity and voice** What does its visual identity (logos, colours, fonts, photography) say? How does it sound? Is it fun and bold or elegant and classic? Does it feel like a transparent friend or an impartial stranger?

5. **Communication and connection** Which channels does it use to communicate and why? How and where does it build genuine connections?

Twelve quick brand questions

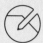 Take some time to consider your answers to the following questions:

1. **What is your brand mission?** What's its purpose? Is it this clear to your audience?

2. **What is your vision?** Where do you want the company to be? What will it become and why do you want this? Do you share this with people who work with you? (Hint: you should.)

3. **What are your values?** Review the work you did way back in chapter 1. What beliefs and values guide your business?

4. **How do you wish the brand to be perceived?** How do you stand out? How is your brand currently perceived? Is there a gap between where you're at now and where you want the brand to be? If so, how will you close that?

5. **What is your brand personality?** What are the human traits your brand possesses (e.g. humour, sophistication, elegance)? Are these shown in a consistent manner across all platforms?

6. **How is your brand positioned?** What is your Unique Selling Proposition (USP)? How does your brand differ to other businesses? How are you unique? Do you intentionally exclude some groups? Why? Why not?

7. **What is the culture you're aiming to build with your brand?** What would your current staff and contractors say about your brand? What would ex-staff say? How is your culture shown in your brand communications?

8. **Who is behind the brand?** Humanising your brand is so important when guiding your audience from a state of Awareness to one of Advocacy. Are you telling the stories of the people behind the brand? Are you telling your own story? #DontBeShy

9. **What is your visual identity?** How do you showcase all of the above with your choice of logo, photography, fonts, visual elements and overall aesthetic? When people glance at your visual marketing materials, how do these make them feel?

10. **What do you sound like?** What is your tone of voice? How does this attract or repel people? Is this consistent across all mediums? For example, some folks reading this will #HateHashtags and that's okay (I'm not for everyone).

11. **Where do you communicate?** Which channels resonate most with your audience? Which do you avoid completely? Are you in constant communication or do you intentionally only 'speak' when necessary?

12. **How does your brand cultivate connection?** How and where does your brand build genuine connections? Are you building a brand people can become loyal to or are you aiming for a slam-bam-thank-you-ma'am brand that people only interact with once?

How did completing that exercise *feel*?

Did your answers flow freely or did you find yourself stuck, unsure and unclear as to exactly what your brand is made up of?

If you're in the latter camp, exhale. Understanding and confirming your brand elements isn't something you check off your list in one afternoon.

It's also not something that you, alone, get to decide on.

Say whaaat?

Yes, friend, you may have just done a whole load of thinking about your brand – you may even have workshopped this with an agency or consultant – but there's one key group missing from this brand discussion.

Your audience.

You can do all the branding work, create the most beautiful logo and communications schedule, detail a positioning matrix and build an amazing company culture but, ultimately, your brand is what your audience decides it is.

What are you the go-to for?

In 2014 I moved into a senior role at a major Australian accessories company. My job initially was to look at the brand content that was being communicated and ensure it met the internal and external needs of the company.

One of the first things I asked my boss was, 'What do your staff say about the brand?' If a staff member attended a barbecue and someone asked the stock standard getting-to-know-you question, 'What do you do?', how would they answer the follow up question, 'What's it like to work there?'

Would their answer be positive?

Would their answer be negative?

Would their answer align with the brand's mission, vision and values?

Let's take it one step further.

This same brand had, at the time, more than 100 stores across three countries, and more than 600 staff working in their stores. Those staff served countless customers day in, day out. What would a customer say to their friends and family about their experience with that brand?

Would it be positive?

Would it be negative?

Would their answer align with the brand's mission, vision and values?

And why would either the staff member or the customer have been attracted to that brand in the first place?

What was that brand – in the mind of the staff member and customer – the go-to for?

When it comes to defining your brand, what do you want to be known for? What are you the go-to for? What's your USP?

We all have certain brands we look at as the go-to for something. It could be for modern streetwear, for ethically made fashion, for cheap groceries, for social media management, for online yoga tutorials, for tech accessories or for that perfect housewarming gift.

What is your brand the go-to for? Why would your audience choose your brand over another? Which traits does your brand possess that others do not?

How does your brand align with the personal values of your audience? Their hopes? Their views on the world? Their heart?

And how does your marketing strengthen or weaken that alignment?

Consider the drivers

Figuring out what you're the go-to for or how your brand aligns to the personal values of your audience isn't always straightforward. One exercise that can help is to look at the emotional and rational drivers that cause someone to want to know about and, eventually, transact with your brand.

It is said that more than 90 per cent of our purchase decisions are made subconsciously (according to Caroline Winnett and Andrew Pohlmann, who formerly worked for the Nielsen Company). Unfortunately, most small biz owners focus only on the rational drivers within their communications (think price, location etc.) rather than the emotional – often subconscious – drivers.

To create a strong brand, you must have a mix of rational and emotional drivers in your marketing and brand communications.

rational driver + emotional driver = brand buy-in

Let's consider my decision to enter into a relationship with my husband.

The rational drivers were:

- Proximity (he lived in the same city as me).

- Age (he is three years older than me, so we're the same generation, get the same references etc.).

- Availability (he was single).

- Sex (he's male and I'm attracted to males).

The emotional drivers were:

- Humour (he was then, and still is, one of the funniest people I know).

- Aligned values (his beliefs mirrored my own).

- Attractiveness (he lives up to the 'Whatta man' lyrics #EnoughSaid).

- Security (he seemed grounded, was employed and lived alone).

- Contribution (he wanted to give back to the world and was aware of the environment etc.).

- Creativity (he had studied Fine Arts (Painting) and was a graphic designer).

The combination of these drivers left me feeling genuinely connected to him. I wanted to know more about him. I was, essentially, buying into his brand (as much as he would hate that analogy!).

Consider the last purchase you made. What were the rational drivers? What were the emotional drivers? Which of the two influenced your purchase decision more?

Did you buy from a brand because they are cheap? Exclusive? Creative? Funny? Close to you? Easily accessible? Aligned to a particular influencer or celebrity? Familiar? Eco-conscious? Trusted?

When it comes to marketing your brand, how often are you showcasing the emotional alongside the rational? Do you favour one over the other? What could you do to ensure both are included in all brand communications?

How will understanding the rational and emotional drivers that influence your audience allow you to understand what your brand is the go-to for?

Need a little more help with this? Consider the concept of Laddering, which is often used to determine why people buy into a certain brand and not another. The higher you can get your audience to climb on the ladder, the greater the chance of them buying into your brand. As you can see opposite, the highest step is where the audience feels a strong emotional benefit when buying from your brand.

Common rational drivers when we're buying into a brand may include:

- Safety
- Economy (price)
- Utility
- Durability
- Versatility
- Convenience
- Suitability
- Security
- Proximity

Common emotional drivers may include:

- Pride
- Prestige
- Sex appeal
- Environmental awareness
- Habit
- Status
- Creativity
- Giving back
- Pleasure
- Emulation
- Aligned values
- Individuality
- Ambition

Originally created by Thomas J Reynolds and Jonathan Gutman ('Laddering Theory, Method, Analysis and Interpretation', *Journal of Advertising Research*, www.journalofadvertisingresearch.com, 1988), the concept touches on four key steps in a 'ladder':

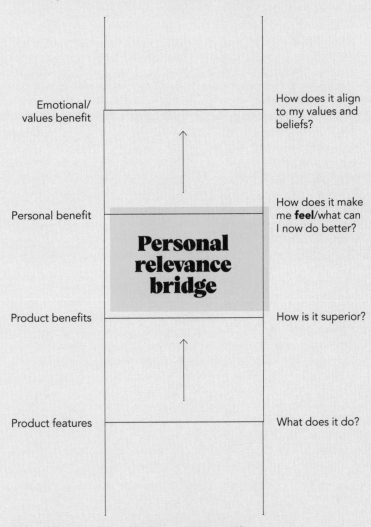

Emotional/ values benefit — How does it align to my values and beliefs?

Personal benefit — How does it make me **feel**/what can I now do better?

Personal relevance bridge

Product benefits — How is it superior?

Product features — What does it do?

Image adapted from The Visual MBA, Jason Barron, p. 49.

When it comes to your brand and its communications, where are you guiding people on the ladder? Are you taking them all the way to the top? Are you helping them build an emotional connection with your brand or are you simply finding new ways to discuss the features of your product or service?

What's your Message Architecture?

Once you understand your rational and emotional drivers, it's time to consider the key messages your brand is putting out. Are your messages aligned across all mediums and departments, or does your social media messaging say something completely different to your messaging at brand events?

Many businesses start small, with perhaps one or two people operating everything. As they gain momentum and achieve financial success, the business grows and the founders hire people, eventually creating teams and departments. What often happens, however, is that the teams begin to form their own ideas about the brand's messages, and you end up with a business that is confusing its audience with mixed messages.

One framework that works well for ensuring that your brand messaging is aligned across all platforms is Message Architecture. I first discovered this tool in the brilliant work of content strategist Margot Bloomstein and her book *Content Strategy at Work* while I was heading up the marketing and content for Amazon UK's Kitchen and Home category.

I wanted to understand how my team could work on consistent messaging despite marketing a category that, at the time, boasted more than eight million products. What were we trying to say? How could we streamline that?

When I moved into a later role, as Brand Content Manager at a large accessories company, I used this framework again to look at how we could ensure that all teams (PR, Digital, Creative, Retail, Design etc.) were speaking the same language, and that our audience – regardless of which touchpoint they encountered us at – would know it was our brand by our consistent and clear messaging.

Investigating this concept further, I came across the work of Hilary Marsh (Content Company, Inc.) and the simple diagram that simplifies what many people find to be a complex topic.

Many brands today work like this, with the brand's message being tweaked and changed depending on the department pushing it out:

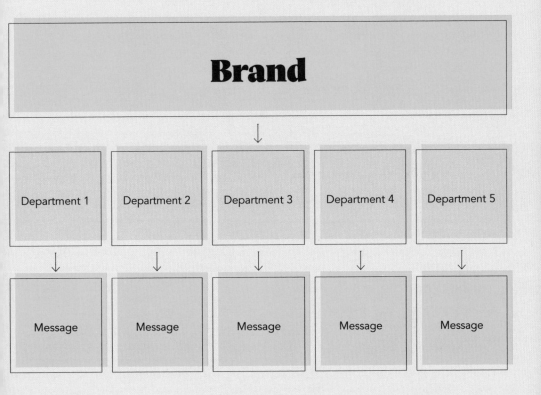

With Message Architecture, the brand's messages are decided on with all key stakeholders, then shared with the entire company. That way they remain consistent regardless of department or marketing channel:

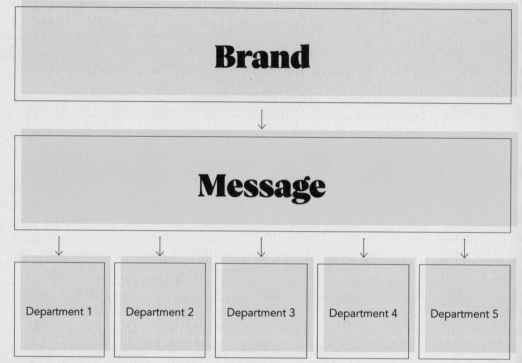

Images on pages 85–6 adapted from Hilary Marsh, Managing the Politics of Content SlideShare, 37–8, slideshare.net/hilarymarsh/managing-the-politics-of-content-psu-web2015.

Margot Bloomstein developed the BrandSort toolkit, comprising ninety adjectives seen in messaging across all industries. There is one adjective per card. You take all of the cards and then work through a card-sorting exercise to decide:

- Who are we?

- Who are we not?

- Who could we be?

You then collate the 'Who we ares' and 'Who we could bes' and begin to group like-minded words together (e.g. cool and hip, friendly and welcoming).

You then cull these until you have the five or six groups that are most relevant to your brand. From each group, you pick one word that is the leader of that group. The remaining words in that group become supporting words.

For example, imagine you had a group of words that included:

- Welcoming
- Friendly
- Fun
- Approachable
- Diverse

You may decide that diverse is the most important word in that group. So, you will have diverse as your lead word, with welcoming, friendly, fun and approachable as supporting words.

From a brand communications point, this means that you want to represent 'diverse' (not necessarily the word itself, but what it means) in your communications, i.e. people of all colours, ages, abilities, nationalities, religions, sexes etc.

Is this just the same as brand values?

No. Message Architecture differs in that it is actually a hierarchy (unlike brand values, which are, usually, all equally important).

For example, if you decide the key messages your brand is aiming to be known for are diverse, empowering, creative, quality and modern, you will need to put them into a hierarchy – in other words, prioritise them. Which of these messages is it *most* important that your brand is known for? Which is the least important? If you can only express one of them via your next social media post, which is most important? You may then decide to list them according to priority:

1. Diverse
2. Empowering
3. Quality
4. Modern
5. Creative

If you think this exercise could be a good one to help you define your brand's key messages, check out Margot Bloomstein's book *Content Strategy at Work* and her BrandSort Cards at cards.appropriateinc.com, plus Hilary Marsh's Content Company, Inc. at contentcompany.biz.

By now you should have an idea of what your brand is the go-to for, the emotional and rational drivers that attract (and retain) your ideal audience and the key messages you want your brand to convey, in order of priority.

Next, it's time to bring all that to life via your visual brand identity. Even if you absolutely love your current brand visuals (and hey, you should), it's worthwhile working through the next step to ensure you have a brand that truly connects with your audience.

Hey, Good Lookin'

Back in chapter 3 we looked at your ideal audience. One of the questions you were asked to consider when creating their profile was their #1 favourite dance track. You know, the one that would have them up on the dance floor, whether sober or not?

One song that fits this criteria for me is George Clinton's 'Hey good lookin''. With a beat you can't help but dance to and lyrics that tell the story of being turned on by someone's appearance, it's an apt reminder that, at least initially, we can all succumb to the way something – or somebody – looks.

While your visual identity is only one part of your overall brand, when it comes to what your brand is saying, its importance can't be overlooked. It needs to be good lookin' to your audience.

Humans are visual creatures. We like being able to visually assess what's in front of us, whether it's a good-looking man at a music festival or a baked New York cheesecake at a rooftop hotel. Those of us fortunate to have sight will make judgements in milliseconds based on the way something looks.

When it comes to your visual identity, you will naturally attract – and repel – people. Everything ain't for everybody. What you're attracted to visually in a brand may repulse your next-door neighbour. Likewise, what turns you off may be just what someone else is searching for.

What does your visual identity say about your brand? How does it communicate to your ideal audience that you're the one they should desire?

In the last chapter, we discussed bringing your audience to life through the visual mood board tool, Pinterest. How does your visual brand identity align with the way your audience sees themselves; their sense of style and aesthetics?

Do your fonts reflect the bold and colourful way your audience wish to live their lives?

Does your photography mirror their aspirations? Is it bright, white and clear or is it dark with moody undertones? Does it have a lot of white space or is every image packed with delicious detail?

Are your marketing campaigns witty and understood by the chosen few, or are they mass market, able to be understood and appreciated by anyone and everyone? Are they funny or serious?

Is your colour palette full of bright, on-trend choices or is it more monochrome and classic?

What does your visual identity say about your brand? How does it communicate to your ideal audience that you're the one they should desire?

Does your visual branding incorporate a print or pattern that you have become known for?

Consider how your visual branding talks to the needs, aspirations and desires of your audience. Is it conveying – through font, colour and imagery – the emotional and rational drivers you now know influence your audience's decision to buy in to your brand?

For example, you may know that your audience has an emotional connection with brands that benefit the planet. Let's say that your business makes wetsuits from recycled plastic found in the ocean. You may then choose to have blues and other colours from the ocean in your colour palette, or even use the texture of sand as a background element in your logo.

One last thing to ponder is the future-proofing of your brand identity. Will it date easily? Can it be added to in the future as your business evolves and expands? Could it incorporate sub-brands if required?

Are YOU part of your brand identity?

The last thing to consider when creating – or revising – your brand identity is what role you, as the founder, wish to play.

Humanising your brand – i.e. showing elements of the people behind it – can be the difference between a brand people like and one that they *love*. Never before has it been so easy to weave yourself into your brand. For some brands that will mean frequent interviews, or images of the figurehead on social media, while for others the founder will be present within their visual brand identity.

One of my fave brands is the US-based accessories and apparel brand Melody Ehsani. Melody Ehsani uses her own handwriting in many of her designs (and even in the tape that accompanies the packaging). Her handwriting has become a key part of her visual identity.

The US-based skincare brand Burt's Bees has an iconic logo that uses the face of the brand's co-founder, the late Burt Shavitz.

As you read on pages 48–51, Sage x Clare founder Phoebe Bell is the face of her business and has been able to use the brand to help support causes she feels a personal connection to.

To what extent will you be a part of your brand identity?

Action

Take a few minutes to reflect on what your brand says about your business.

Then answer the following questions in as much detail as you can.

1. How much of your brand have you worked on? Go through the twelve quick brand questions on page 78 and look for any gaps in your brand knowledge.

2. What do you want to be the go-to for? Is that clearly communicated in your current brand messaging?

3. What are the emotional and rational drivers that help your audience buy into your brand?

4. What is your brand's Message Architecture? What are the key messages you want to convey to your audience across all touch points?

5. What does your visual identity say about your brand? How does it communicate to your ideal audience that you're the one they should desire?

6. How much of you will be present in your brand identity?

Nick Shelton, *founder, Broadsheet*

Nick Shelton is the founder, director and publisher of Broadsheet. Since starting the company by himself more than a decade ago, Broadsheet has grown to become one of the most recognisable and trusted brands in Australia, providing information about culture, cuisine and creativity to its loyal audience through its online and print publications. As the brand has grown, so too have its offerings, with the successful launch of Broadsheet cookbooks, restaurants, cafes and, most recently, Broadsheet Editions – a curated suite of photographic prints available to buy from Broadsheet photographers.

How would you describe Broadsheet?

Broadsheet, at its core, is an online digital media brand that covers the best things to do in your city. We operate in Melbourne, Brisbane, Sydney, Adelaide and Perth. We cover all the great lifestyle and cultural components of living in a city. Its restaurants, its bars, its fashion, its travel, its entertainment, its theatre, its music, its art, its design.

It's even, now, active, so the way we practise yoga and Pilates, and go for hikes, go swimming and biking. It's everything to do with making life in your city great. Beyond just the website we have a quarterly print publication. We publish cookbooks featuring the city's best restaurants. We do pop-up bars and restaurants. We do anything that's about connecting our brand and our audience through city lifestyle.

Back in 2009, you initially launched online and shortly thereafter added a print publication. Did you have any experience in publishing?

None whatsoever. The idea was always about having a publication. It was all born out of my frustration that I wasn't getting that content. The media wasn't covering Melbourne in the way that I, as a twenty-four-year-old, really wanted it to be covered. There was no online resource where I could say, 'I want to find a cool place for breakfast with some friends in Fitzroy. Where should I go?' It just didn't exist.

The online component was always the piece I saw first. But then I quickly realised that if you set up a website it doesn't mean that people are going to find it. So the print publication started as a, 'Why don't we print some flyers and put them in some cafes where people are? Great. We have all this great content, so why don't we put some content on the flyers? Well, now we're talking about a little book. We'll call it Broadsheet, so we better do a broadsheet', so we made a little paper.

It evolved in that way. It was really just a marketing thing. It was about getting our brand and our content, that we were really proud of, to where people were. That's in cafes, bars, shops and restaurants. We started there but it was always about building the brand and then driving people back online.

Photo © James Geer

When you started your business, you went out and found people that you could talk to. People in hospitality, people in publishing. How did you go about doing that?

I remember having a really clear idea of what Broadsheet would be, coming back from London. I was sitting in the car somewhere talking to my dad about this idea. He just told me, 'Okay, why don't you go and speak to X, Y and Z (family friends) who may have something to do with technology or media?'

From there it was really working backwards on a business plan. When you write a business plan, you've got all these headings. This is the top-line plan, this is the marketing plan, there's a competition, there's the SWOT analysis. Then thinking, 'I need to do a financial model as well. I need some assumptions to put in here. I need to validate those assumptions or even begin to know where to pop that assumption down. So it was just about going out and validating those assumptions, asking questions and looking at the blank parts in my business plan and asking: 'How am I going to fill that out?'

I would just call, send emails … I'd never leave a conversation without two more people to go and speak to. I spent about a year doing that and then compiling that into a business plan, which I never actually showed anyone. It was never something that I took out and said, 'Here's my business plan, will you fund it?' It was more of an intellectual exercise – wanting to clarify in my own mind what I was actually doing, did this make sense and did part A connect to part B?

Some seasoned business owners still find contacting strangers difficult. Did you get nervous?

I probably did at the beginning, looking back on it. Someone once told me, 'You're naive and that's a benefit because people won't hold strange requests against you. They'll just say, 'Oh, he's a naive twenty-four-year-old. Good for him.' I was told, 'You'll have that for three years, but after three years you're going to have to know your shit,' which is naturally what happens. I think

just getting on the phone to people and chatting to people helped; nine out of ten people were really happy to have a chat.

How did you sell the idea? Was advertising one of the main income streams?

It was, but it wasn't the focus for the first year. The first challenge in terms of selling it was about selling the concept. Even those people that I was talking to who had nothing to buy, it was really just about trying to get their attention. And what I found was when I was talking about it, they would dismiss it. Not all of them, but many would say, 'Doesn't that already exist? I think I've seen that somewhere.' And you think, 'No, that's not what I've got in mind. It's actually something different.'

I worked with a design agency, Studio Round, and was really fortunate to work with them, because they not only understood what I was doing but they added a lot of value to it. They brought it to life in a way beyond what I imagined. Working with them led me to have three A3 print-outs. I would show people, 'This is the homepage, this is an article page, this is what a directory looks like.' Then they'd say, 'This is cool, I see this. Yeah, I can really imagine how that works.'

Once I had that, it was really helpful in terms of getting that first step up. It just grew organically. I hired an ad salesperson who was terrific at selling the vision and selling the product. It snowballed from there.

Did you get investment at the start?

No. I decided not to go down that path because it was really just, 'Let's test and see if this works'. Cost discipline is something that has been a big part of the success. It's not about saying this thing's going to cost two million to build and I'm going to go and raise that money and spend it. It's about saying, how much can I afford to operate within? The first step of the business was: can we build this into a sustainable business? Can this business pay for itself? That's the first thing it's got to do. Once it does that, can we then grow it? That's been the journey.

In the last decade you have diversified massively – cookbooks, restaurants, cafes and so much more. Can you talk through the process of deciding what to do?

It's probably evolved a lot in the last decade. Back in the day when we first started doing things like pop-up cafes, that was about a couple of things. Most of the time they were because we needed to continue to build our brand and do interesting things. But can we do that in a way that covers their own costs? Because we don't have tens or hundreds of thousands of dollars to go and build a restaurant. If it covers its own costs then maybe we can do that.

We just didn't have the money to go and waste it, you know? It was about do we really want to do this, what's this going to add and, most of all, can it pay for itself?

There are certainly pros and cons of doing that, especially when you're small. The first time we did it, we were probably a four-person business. It shuts down the whole business for that time. But it really did help us build our brand. Our approach to all these projects, as a modern media brand, was: it's not about having a website, it's about having a brand, an audience and a connection between those two things.

However we connect our audience, our brand and the brand's point of view, that's media. A cookbook is media, a restaurant can be media as well. The plate you put down in front of someone at an event can be media. That's been the approach.

You're a quiet-ish guy, which goes against the stereotype of an outgoing, big empire-building CEO.

I'm pretty outgoing but I'm also pretty balanced in that respect. I think it's more about having confidence. It's about having confidence in yourself, in your vision and in your team. If you've got confidence, then as long as it's not misplaced, there's nothing to stop you. I think it's insecurity, it's doubting yourself, doubting your team or doubting the resources you have around you – that's what's going to get in people's way. If you're confident and you're clear about where you're going and where you want to be, then I think you're okay.

Do you have people that you seek out for business mentorship?

I haven't got formal mentors. It's probably trying to identify people who can help with something depending on what I need. In the early days I didn't have a problem picking up the phone or sending an email and saying, 'Hey, would you have an hour for a cup of coffee? I want to bounce an idea off you.' Or, 'Can you introduce me to someone who can explain it?'. I try to tell myself to do this more and more because I just find it so helpful. Meeting people in different fields always leads to good things.

Is there a mantra or quote you come back to?

No quote as such. What I come back to quite a lot is: don't blindly accept conventional wisdom. That's what I had to tell myself when I was starting this thing, because you'd go and talk to all these people … Nine out of ten people would say, 'This is interesting, but you're nuts. Don't do it.' I had a really clear vision for my business. It wasn't about blinding dismissing others' advice, but it was about taking that advice and processing it through a filter of: do I already understand that? Is what they're telling me something that I already know and have considered? Just because it hasn't been done before, it doesn't mean it can't be done.

What legacy do you want Broadsheet to have?

For me, it's about having this brand that people love and that's really adding value to people's lives. I think that's going to be what it's measured on. As long as we're continuing to do that and adding to people's lives in a meaningful way and doing it really high quality, then I'm happy.

broadsheet.com.au

[image] @broadsheet_melb

[image] @broadsheet_syd

Where will you connect?

I have two young children. Needless to say, I savour time alone and sleep.

When I get the chance to travel to Sydney for work (or, less often, for pleasure), I will always stay at the same hotel. In addition to being located right in the heart of Sydney (rational driver), I absolutely love the *feeling* I get when I arrive (emotional driver).

I have stayed at this hotel at least eighteen times. Is it the cheapest? Far from it. Is it the most soundproof? Not always. Is it the most beautiful Sydney has to offer? I doubt it.

But there's something about this hotel that makes me come back time after time.

Perhaps it's the front desk service – never pretentious, always friendly and eager to make me feel like a valued customer. (*Hi again, Ms Killackey, what are you working on in Sydney this time?*)

Perhaps it's the fact that they always book me into the same room, ever since I told them, many stays ago, that I really liked the view.

Perhaps it's because when I enter the hotel room, there's soothing music playing, dimmed lights and a sense that you can truly relax.

Perhaps it's the complimentary drinks on offer, or the endless array of new release films. Perhaps it's the way the bath is positioned, so while watching a #sneaky midday film between meetings, I can also indulge in a soak.

Perhaps – and this is most likely – it's that their marketing works for someone like me.

As I touched on in chapter 2, marketing is simply a process of guiding people through three main stages:

1. Know

2. Like

3. Trust

I knew about this hotel well before I stayed there, through friends and clients who raved about it. The first time I stayed there, I liked it so much I suggested that my husband and I have a fun weekend away so that he could experience it too. My subsequent stays cemented the trust I have that every time I stay there, I will enjoy the experience.

This, my friend, is what marketing is all about. Cultivating connection that encourages conversation, community and conversion.

Are you surprised? You shouldn't be.

Too often, small biz owners view marketing as a push-push-push sales message (think fire-engine red font, all caps and shouty banners) rather than seeing it as an opportunity to pull in your ideal audience, attracting, engaging and retaining them with experiences they value (and then tell everyone about).

In this chapter, we will look at the ways you're enabling true connections to form between your brand and your ideal audience. We will work through your inner marketing hater (#WeAllHaveOne), map out your ideal customer journey, touch on the marketing channels most suited to your business needs and make a commitment to consistent connection.

Marketing is all about cultivating connection.

Set your inner marketing hater free

The first step when discussing marketing is to set your inner marketing hater free. After working with hundreds of small biz owners and teaching thousands, I know that most, if not all, possess a marketing hater.

I'm talking about that inner voice that hears the word 'marketing' and immediately responds with:

- *Marketing is lame.*
- *Marketing is unethical.*
- *Selling is for sellouts.*
- *Marketing is total BS.*
- *Marketers prey on people's vulnerabilities.*
- *If I'm good enough, people will just find me!*
- *I can't market my business, I'm an introvert.*
- *Marketing kills my brand's cred!*

- *Marketing is expensive.*
- *Marketing is too confusing!*
- *Marketing is for people without souls.*
- *I hate marketing because I hate technology.*
- *Marketing is like being a used-car salesman.*
- *Marketing spies on people.*
- *Marketing is scammy.*
- *Marketing won't work for my business!*

Maybe you think marketing is all about 'selling out', or that it's just posting selfies 24/7 in order to gain followers. Maybe you hate the way other brands market themselves, and don't believe there's another way.

What does your inner marketing hater tell you?

What are the blocks and beliefs you have when it comes to marketing? Where do you think these come from? How have they served you in your business (or in your career to date)?

Spend some time considering any negative feelings you have about marketing. Acknowledging these is the first step in being able to use marketing to grow your business.

Where are you leading people?

Remember E St Elmo Lewis, the man we discussed in chapter 2, who came up with the AIDA (Awareness or Attention, Interest, Desire, Action) framework? He understood that, regardless of what's being offered, a person needs to work through a journey in order to transact and form a relationship with a business.

When it comes to working out what kind of marketing you need to scale your business, it's worth mapping out what an ideal customer journey looks like for your business.

The easiest, quickest way to do this is to get out a pen and paper and draw an arrow from left to right, like so.

AWARENESS ADVOCACY

This is the ideal journey your customer will take from the time they first hear about your business (Awareness) through to the time they fall in love with it (i.e. Post-purchase/Advocacy).

You want to mark in all of the key touch points they'll interact with, and any marketing materials they'll see/receive up to, and beyond, the point of sale.

For example, let's say you're an online parenting coach offering courses and education to new parents.

Your ideal journey may look like this:

Google Adwords

WOM

Networks

Flyer at event

Media/PR

Social media

Influencer Initial call

Advertising Calendly Booking

Referrals Zoom Members' area

Podcast Typeform access

Website Proposal

Social media Welcome seq.

Re-marketing - Testimonials

Opt-in - What to expect

Typeform (on contact - Need to know
page)
 - Next meet-up
- About video

The reason it's an arrow, and not just a straight line, is that the journey doesn't end. Your Post-purchase/Advocacy marketing (retaining clients/customers) is just as important as your Awareness marketing (gaining new clients/customers).

Spend some time mapping out your ideal customer journey.

If you're already in business, review the marketing you're doing at each stage in this journey. Where are people dropping off from a lack of information, quality experience or perceived value? Where is your marketing not working?

The marketing journey doesn't end.

First year email sequence
(Videos + prep)

- Initial call

- Next steps

- Video course
 commencement

Retention

Referrals

First birthday
follow-up

$

Agreement

Contract

Invoice

Call info

Ebook

Video from founder

- Gift for child

Live workshop feedback
(Survey Monkey,
Typeform)

Testimonials (in email
request)

If you're yet to launch your small biz, consider the touchpoints you'll want your audience to move through before, and after, they transact with you.

You may choose to have multiple customer journeys according to the various products/services your biz offers.

While this exercise does not negate the need for a full marketing strategy, it will help you consider how you're asking people to know, like and trust you, as well as enabling you to remove any marketing you're doing that has no real impact on your ideal customer journey.

Choosing your channels

Now that you're aware of the journey you want your customers to take, you can begin to look at the best channels to cultivate connection. Given there are literally thousands of options here, and constantly evolving platform choices, one way to consider your channels is to work through the Five Ws again.

Don't be fooled into only considering digital marketing channels. One of the best ways to connect with your audience and cultivate a community is to meet them in real life, whether that's via an event, trade show, a physical space such as a pop-up store or even one-on-one meet-ups. Failing that, video conferencing or going 'Live' on social media can be a great way for your audience to see more of the human element (aka YOU) behind your business.

Still need help?

On the opposite page is an example of some of the best marketing channels at each stage in the Buyer Cycle.

WHO?

Who am I trying to target? Who is their circle of influence? For example, media/influencers/friends/news channels?

WHAT?

What content will they connect with? What mediums do they prefer? Audio on-the-go, blogs, emails, videos?

WHEN?

When do they most need this? For the last few years I have sent a Sunday night email to thousands of small biz owners, who are busy during the week but have enough downtime on Sunday to read, digest and action the insights I share. When does your audience have the time to connect with your brand? For example, buyers at a trade show will come with high intentions to discover new brands and chat with business owners. When will your audience convert? For example, in my one-on-one coaching, 90 per cent of the time the conversion happens over the phone.

WHERE?

Where are they most likely to connect? For example, would busy parents prefer a podcast or an early morning event (possibly not the latter if they're rushing to get kids to school)? Where do they hang out? Where is their circle of influence? Where are they seeking what you offer?

WHY?

Why will this marketing channel help them move through the Buyer Cycle? For example, does it have direct links (Pinterest/LinkedIn) so they can click to buy? Do they need to meet you (i.e. at events) in order to commit?

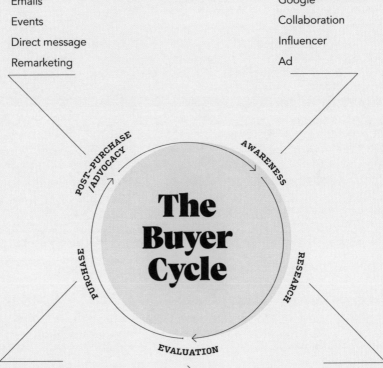

Social media

Word of mouth

Media

Google

Collaboration

Influencer

Ad

Emails

Events

Direct message

Remarketing

POST-PURCHASE /ADVOCACY

AWARENESS

The Buyer Cycle

PURCHASE

RESEARCH

EVALUATION

Product detail page

Store/stockists

Ads

Emails

Remarketing

Direct message

Events

Website

Store/ stockists

Reviews/ testimonials

Emails

Events

Social media

Google

SEO

Website

Review sites

Amazon

Facebook

Google My Business

Store/ stockists

Validating your assumptions

When looking at the marketing you need to use to connect with, and convert, your audience, it can be tempting to assume all of your ideas are correct. If you haven't been able to test and tweak your ideal customer journey before, it pays to spend time validating your assumptions.

How?

- Ask current customers/clients about the marketing channels they use in a survey, phone call or direct email.

- Use social media. For example, polls on IG stories (e.g. would you rather X or Y when choosing your engagement ring online?).

- Watch people #IRL work through your website or physical space. Look at where *they* think they should be moving vs. where you would like them to be moving.

- Check feedback on competitors via Amazon and Google My Business reviews (those three-star and under can be a goldmine when it comes to finding ways to improve your customer journey).

- Test, test and test again. You won't know what you need to tweak until you start doing this.

Validating assumptions may take time, but it's far better than rushing into marketing tactics that then don't perform in the way you'd hoped.

Decoding the data

Have you ever tried a new marketing tactic that didn't 'work'?

What does not 'working' mean to you?

Creating your marketing and measuring its performance are two different things. Many small biz owners get excited (and then somewhat deflated) about the first, without ever putting time and effort into the second.

Marketing should always have an objective, whether it's to increase brand awareness, drive traffic to a site, increase conversion or opt-in rates, result in sales or customer inquiries, increase frequency or value of purchase and/or grow your market share. That objective then needs to be measured, usually by way of data and analytics.

Too often I see small biz owners pour money and time into platforms and marketing tactics without a clear objective.

Consider the marketing you do in your small biz (or the one you hope to start). Do you know its objective? Are you measuring regularly against this?

Too often I see small biz owners pour money and time into platforms and marketing tactics without a clear objective.

Are you marketing on platforms (such as certain social media tools #hmmm) purely because you think you should, as opposed to knowing that this is a) where your audience most wants to connect with you and b) the channel most likely to help you meet your objective?

If I asked you to create a pie chart of your marketing channels overlaid with the percentage of sales each brings in, could you?

Likewise, do you know which of your marketing channels help build your brand vs. those that help you in the last stage of conversion?

Review the Five Ws on page 104 for your marketing channel choice. How can you then create systems and processes that enable you to set an objective for each channel and measure how well it's performing for you?

A great place to start with this is to map your marketing channels against the Buyer Cycle, then set up automated reports (using a tool like Goals within Google Analytics) to show where the drop-off happens, where the conversion happens and any other useful data that can help you decode the seemingly mysterious world of marketing.

Committing to consistent connection

I am a huge fan of podcasts, even hosting my own. A few years ago I found out that someone I admire was launching a podcast. I eagerly subscribed and listened religiously, week in, week out. One Thursday I looked for their podcast only to see that it hadn't been updated that week. Eventually they released another episode, but then it was another month between that one and the next.

A lack of consistency can be one of the biggest killers of great marketing. I have written a weekly email since early 2017. There have definitely been weeks when I've had a whole load of life stuff going on and the idea of just not bothering with the email has been sorely tempting. But! It is not the fault of the people on that email list – who perhaps need to hear what's in this week's email – that I didn't have the time to write it.

When I asked them to subscribe to my email, I promised to deliver weekly biz insights. Weekly. Not monthly or fortnightly or whenever I felt like it. In order for them to continue trusting me, I need to ensure I step up and commit to the promise I made.

When it comes to your marketing, you need to commit to consistent connection in your chosen channels.

How often will you show up? What can you commit to?

Remember, it is better to show up less regularly but consistently, than to promise to show up more frequently and then give up when you realise you can't commit.

Action

Take a few minutes to reflect on where you will connect with your audience.

 Then answer the following questions in as much detail as you can.

1. How are you enabling Know, Like and Trust to happen?

2. What does your inner marketing hater say? Where did this come from and how has it served you?

3. What is your ideal customer journey? How is your marketing helping or hindering this?

4. Using the Five Ws as a guide, which marketing channels will you use to connect with your audience, cultivate a community and convert browsers into buyers?

5. How and when will you validate any assumptions?

6. Which data will you use and how often will you commit to analysing this (i.e. Daily? Weekly? Monthly?)

7. What frequency of connection will you commit to? Remember consistency is key.

8. How does your marketing reflect your 'why' and the needs of your audience?

Marawa Ibrahim, *founder, Paradise, Marawa's Majorettes and Marawa The Amazing*

Marawa Ibrahim is a world record–holding hula hooper, performance artist, entrepreneur, teacher and author based between London and LA. Her businesses include Paradise (a shop selling everything from rollerskates and hula hoops through to apparel and accessories), Marawa's Majorettes (an all-girl hula hoop troupe) and Marawa The Amazing (Marawa's physical performances). In the past ten years, she has collaborated with numerous global brands, including Kenzo, Puma, VICE, Cos, Refinery29 and Monki.

What was your upbringing like? How did it influence what you have decided to do for work?

My parents always travelled, so I have always been more comfortable moving around than staying in one place for too long. I was really unsure about what I wanted to do for work, but I knew how I wanted to live! So I looked for something that would support that.

You dropped out of studying science at university to study at the then-new National Institute of Circus Arts in Australia (NICA). How did this happen? What did you hope it would lead to, career-wise?

I had no idea where studying at NICA was going to lead me, but I knew it felt right. When I finished high school and had that HUGE telephone book–sized list of courses in front of me, I couldn't understand how I was meant to narrow it down to one thing. It seemed impossible and crazy. I started studying Social Science Interactive Multimedia, but my heart wasn't really in it. I liked the writing and the sociology subjects, but that was it. NICA fascinated me – it was a brand-new degree – and

conveniently was at the same university I was studying at. I wasn't sure where it was going to lead, but I knew that I was inspired and excited to be there. Thankfully, as the course went on, I worked out a way to turn it into the career I wanted.

You boldly headed to NYC to pursue performance. How did you initially land roles and survive over there? What advice would you give to someone looking to do something similar?

I was so lucky, I headed overseas performing for the first time in 2007. MySpace was poppin', Facebook was taking off; it had never been so easy to connect with people who had similar interests. I would search groups, forums and events for anything related to hula hoops, circus etc., and then reach out. I had a website with my info and acts. I had enough money saved up to make sure if I was ever stuck I could always go home.

It was a great time. I met so many people who were like-minded strangers that became, and still are, close friends who I stayed with while I travelled all over the

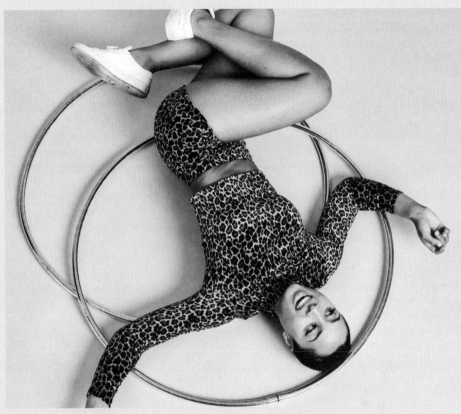

Photo © Jo Duck

world performing, learning, and trying to work out where I wanted to be and what I wanted to do.

You need to have a plan – even if it's as loose as 'I want to spend three months overseas'. Then you need to have a realistic amount of money saved up, which allows for emergencies etc., and a ticket home. That's all I needed to feel safe … then I just went for it! My initial trip was a round-the-world ticket and six months of travel that was loosely mapped out (and changed a lot). I never used the second half of that ticket and didn't go home for a year!

Today you have multiple businesses and you spread your time between London and LA, as well as family time back in Melbourne. Do you believe you had to move away from Australia to bigger cities in order to achieve what you have?

For my industry there is a much bigger market in Europe than Melbourne. I think I could have done something similar in Australia, but it would have been much harder work and probably not as financially rewarding – there are just a lot more venues, events and year-round activity, as Europe has the Christmas season and also the summer season, whereas both things happen at once in Australia.

You have had such a varied performance career. How have you done this?

Initially it was about doing everything possible to get work and get seen. I would take every gig, because even if it wasn't super well-paid I would always meet someone else who would want to book me. Being seen performing was always the best way to get booked. Trying to explain to someone what I did never seemed to work. Over time I was able to show people more of the work I wanted to do, which would lead to more people booking it. In the arts I think there is a lot of needing to show people *what* you can do rather than waiting for the perfect gig to appear.

You have encountered some pretty massive names/designers being, shall we say, *inspired* by your work. How do you deal with this? What advice would you give to other small business owners who may feel like giving up when they see the big brands doing similar things to them?

I think it's motivating more than anything. It's frustrating, sure, and I think it's easy to get pulled down by stuff like that, but there is only so much you can do. If it's not something you can take on legally then it's usually just two options: let it destroy you, or move on.

I have realised over time that being creative – truly creative – means that you don't have a limit on ideas. That's your skill. Running a business and making money off those ideas – that's a different set of skills! Big brands have big budgets and endless resources, but [they] are also limited with structure, inflexibility and 'too many chiefs'. I prefer the freelance route every time!

Where do you seek advice or mentorship when it comes to business?

I had a business coach all of 2018. I loved working with her; she gave me a lot of structure and helped me really step outside my work and think about what I want to do with the next phase of my career. It's been great to set new goals and work to achieve them. It can be easy to get stuck in a rut when you don't have someone checking in on your lists that holds you accountable.

Have you had to hire people for your business? If so, what has that process been like and are there any lessons you can share to help other small business owners who may be hiring people for the first time?

I don't hire hoopers!!!!!

At first I thought it made sense to hire someone that hooped – but what I really needed was help not related to hooping at all. I needed people that were good with spreadsheets or design etc.!

Advice? It's good to be really clear about goals, timeline, fees etc., so that there are no surprises or ruined friendships. :)

Are there any mantras or quotes you come back to again and again, in relation to your business?

Get on with it.

Finally, what do you want your business's legacy to be?

A whole life built on hula hoops. Genius!

marawa.online

 @marawa

Photo © Jo Duck

How do you make money?

PAGES 115–137

In early 2001 I bought a one-way ticket from Melbourne to London. Despite being born in England, I knew just one person living in London, an old school friend I hadn't seen since we graduated together in 1997.

Once I bought my ticket, I went online, found myself a flatmate – from some dodgy site; remember, this was years before social media – spoke to her on the phone for all of ten minutes (due to the cost) and promptly got ready to take over London.

Yes, take over.

At the ripe old age of twenty-one (and three days!) I thought I would conquer London. In my naivety, I had lined up an internship at a top women's magazine and thought I'd land a paid job there within a few weeks. After all, I had big earrings, homemade leopard-print outfits, a cute haircut and an Arts Degree. Who wouldn't snap me up?

As hard as I tried in my internship, there was no job for me in the foreseeable future. A few weeks in, a fellow intern told me she had been there for two years, working full-time during the day (completely unpaid) and then working in bars at night, sleeping on friends' couches and waiting for her big magazine break.

I promptly quit and found a job in a very small, family-run advertising agency in Shadwell, in London's (at the time) grimy East End. For my role – as the Executive Assistant to the Director – I was paid exactly £240 per week (before tax), a little more than £6 per hour. My rent was around £400 a month. Needless to say I wasn't exactly cashed up. I would accept any and every offer of food and wine from my flatmates and use the free bread, butter and coffee in the office kitchen for my lunch. There were many, many times I'd stand in the line at Tesco supermarket, silently praying that my purchase would go through.

Fourteen years later, when I decided to quit my well-paid six-figure role, I was met with flashbacks of that time in London.

I don't come from a 'rich' family, and I don't have the luxury of being able to quit a job without money coming in. I have been working since I was legally able to get a job, at fourteen years and nine months (#CheckoutChickRepresent). What's more, the month before I decided to resign, my husband and I had settled on our first home. We had a two-year-old in childcare three to four days per week (with an average daily charge of $108) and a truckload of moving expenses. It wasn't the ideal time for me to start a business. But, as they say about having a baby, if you wait for the perfect conditions you will be waiting forever. I knew that starting a business was something I had to try. I also knew that, for me, the older I got and the more accustomed I was to a regular pay cheque, the harder it would be to take that leap. It really was a case of now or never.

Making money is one of the most important parts of business. Being able to pay yourself a wage is imperative for success. Despite this, hundreds of businesses are started every day without thought being given to how they will bring in an income. This is why, according to recent Australian Bureau of Statistics data, almost half of new businesses don't survive their first three years (in Australia at least). As harsh as it may sound, if you're not making money, you have a hobby, not a business.

In this chapter, we will dive into the tools I used back in 2015 to map out my money and create a business that could not only survive, but thrive. The following tactics are all tools I use to this day in my own business and with the hundreds of small biz owners I work with.

Ready?

Let's talk about cash, baby

For some people, money is a taboo subject, while for others it's something they feel comfortable discussing. I'm in the latter camp and I know, unfortunately, that I'm also in the minority (#SadFace).

The idea of being open about money probably feels about as comfortable as walking naked into a school reunion. As you work through this chapter, it's important to be conscious of your own issues when it comes to money – aka your *money mindset*.

 Take a few minutes and ask yourself the following questions:

- How does talking about money make you feel?

- What are some of the beliefs you have around money? For example, do you think wanting more money makes you greedy/selfish?

- Do you avoid talking about money with friends and family? If so, why?

- Do you put limitations on your ability to earn?

- What does financial success mean to you?

If you do nothing else, take the time to consider that last question.

What does financial success mean to you?

Your money goals are *your* money goals. No one else's. When it comes to defining success, *you* are the only one who can do so.

For me, financial success relates to one of the 'whys' behind my business: freedom.

Having money affords me the *freedom* to choose who I want to work with and the type of projects I take on. It gives me the freedom to take time off work to spend more time with my elderly father, hang out with my children, visit a friend who lives outside of Melbourne or even just go and see a movie midweek on impulse. To me, financial success also means being able to travel overseas at least once a year with my family, being able to attend conferences I know I'll find inspiring, paying off our mortgage early, being able to update my office equipment, being able to buy 'just because' gifts for my husband and being able to shop at a supermarket and never, ever, worry that the transaction won't go through.

We are all different; one person's version of financial success is not someone else's. It's important to consider this on your own. It's far too easy to be influenced by others, when ultimately it is you who must decide what you're working for.

What are your numbers?

A practical way of working our your numbers is to define your Survive and Thrive figures.

What is a Survive figure?

When I decided to quit my job back in 2015, I sat down and worked out the absolute minimum I'd need for myself and my family to survive. How much money would my business need to bring in to cover my contribution to our household (mortgage, insurances, childcare, student debt, food, petrol, tax, holidays etc.)?

This was my *Survive* figure.

How did I know how to do this?

If you have ever bought a home and worked with a mortgage broker, you may have had a conversation about your base financial requirements. This is, in short, how much money you need to survive – an important figure to identify when you're looking at the most expensive thing you'll ever invest in (i.e. a house).

When my husband and I met with our mortgage broker in early 2015, we were shocked at the survive figure he told us was 'standard' for a two adult, one child household. *We're different*, I thought naively. *We don't have expensive taste. We certainly don't spend anywhere near that figure every month.*

A few minutes later, I sat there stunned as the mortgage broker worked through our expenses and tallied them up only to arrive at the same seemingly-outlandish 'standard' figure he had mentioned moments before.

It's a fact of life: things add up.

My mortgage broker was the first person to ever relay Parkinson's Law to me in relation to money. Parkinson's Law (*Parkinson's Law: The Pursuit of Progress* (London, John Murray, 1958)) is the idea that work expands to fill the time available for its completion. My mortgage broker applied the same concept to money; the more you have, the more you will spend. Prior to going through our household expenses with him, I had no real idea of how much we were spending despite me being the person in charge of our banking. Yes, I was earning more than I ever had, but I was also spending more than I ever had. I had a general idea of what the big items cost – rent, insurances etc. – but I wasn't watching the smaller expenses that were, over time, adding up.

By understanding the amount of money you need to simply *survive*, you can begin building out the revenue goals for your business.

When I decided to resign from my job, I looked at where I could cut back on spending and worked out the bare minimum the business needed to bring in so I could contribute to our household and pay myself a wage. This gave me the confidence to resign and start my own business.

Take some time to look at what you need simply to *survive* and how much your business will need to bring in to cover the bare necessities. For example, your contribution towards your household may be $1000 per week (after tax and superannuation contributions). You decide to pay yourself a wage of $5000 a month. Your bare necessity business expenses come to $800 per month. A rough calculation would see your Survive figure at $5800 per month (after taxes and superannuation have been taken out).

Some people may not have to contribute to their household, so their Survive figure will be low. Others may be the main 'breadwinner', so their Survive figure will be higher.

Even if you have been in business a while and already pay yourself a good wage, this is an important – and eye-opening – exercise to complete.

What is a Thrive figure?

Let's be real, coming up with your Survive figure can be a little #depressing. Many of my clients are shocked at how much they need just to survive. Hopefully the next part of this exercise – coming up with your Thrive figure – is a little more exciting.

Your Thrive figure is the amount of money that will allow you to feel you're *thriving*.

How each person defines 'thrive' will differ, but it's really about all the *extras* you would like your business revenue to contribute to.

For some small biz owners, these extras will include:

- Renting a new studio or office space.
- Travelling regularly to network or research industry trends.
- Taking extended annual holidays.
- Updating or implementing uniforms.
- Providing staff bonuses.
- Donating to charities of choice.
- Updating equipment.
- Opening another physical store.
- Shooting more frequent campaigns.
- Working with celebrities or influencers.
- Hiring (more) staff.
- Paying yourself a certain salary … and so on.

WHY IS THIS FIGURE IMPORTANT?

Too often I meet with people who tell me they would like their business to make $X. When I dig deeper, it turns out that $X is simply how much they earned in their last role. This is really just some arbitrary figure that your last employer considered you worthy of. It does not reflect what you, specifically, need to make in order to not only survive but also thrive. It also fails to take into account all the extras you may have received in your last role (above and beyond your salary), such as paid sick leave, accrued long service leave, compassionate leave, parental leave pay, superannuation/pension/401K, training expenses, conference expenses, travel, clothing allowance, car allowances and so on.

Knowing your individual Thrive figure is key to planning out how your business will operate and what it will offer.

WHAT IF YOU FIND YOURSELF IN A THRIVE BLOCK?

Completing this exercise can often result in a Thrive block.

A what?

A Thrive block is when your brain comes up with a reason to stop you from believing in your Thrive figure. When you begin to visualise what you really want in your life and how your business can aid you in securing those dreams, your mind will automatically go into risk management, relaying all the reasons why your Thrive figure is unrealistic.

These are some of the most common Thrive blocks I hear from clients:

- I'm not good enough.

- I don't have X number of followers/email subscribers.

- This is so unrealistic.

- I'm just being greedy wanting this much money.

- To earn that, I would need to work 24/7 and never see my family.

- My business/industry isn't one that makes a lot of money.

- I have never earned anything close to that so I know it's not possible.

- Making that much would mean way more stress.

Be conscious of your own Thrive blocks. Sure, your initial Thrive figure may seem outlandish or even unrealistic but, like so many things in life, what seems impossible today can often become our reality tomorrow.

I've had clients hit their five-year revenue goal (we're talking in the millions) within twelve months, and others make more money than they could have imagined just weeks after starting their business. When I started my own business, I initially (stupidly) told myself I would *never* be able to make the same amount as I was earning in my last employed role. Four years on, I make a whole lot more money than I did then, all while working far fewer hours.

Take some time to consider what you most want from your business. What figure would make you feel like you were thriving, not simply surviving?

What stories do you need to change in order to believe that this is possible?

Feeling the flow

Now that you have an idea of your Thrive figure, and of what financial success means to you, it's time to map out how you're actually going to make that happen.

How does your business make money?

- Do you sell products?

- Do you sell services?

- Do you sell a mix of both?

- Do you get money by being an affiliate for other businesses?

- Do you get money via partnership agreements?

All of these are examples of *revenue streams*.

Regardless of what your business offers, you will have a way of *making* money. It may be that you sell products online as well as via retail stockists. In that case, two revenue streams for your business would be online sales and wholesale sales. Likewise, if you sell services you may have one revenue stream that's for online courses and another for one-on-one coaching.

Once you have your Thrive figure in mind, it's time to look at which revenue streams will help you achieve that. One way to work this out is to create a mind map, which is simply a visual diagram that shows how your Thrive money will be made.

First, place your Thrive figure in a circle in the middle of a page. Around this circle, write your revenue streams.

For example, if you have a Thrive figure of $100,000 and you're a product-based business, you may have the following revenue streams:

- Online

- Wholesale

- Pop-up store

- White label

> *It's important to point out here that more revenue streams doesn't always equate to more money. In fact, having too many revenue streams – particularly if you're a solo operator or just starting out – can be overwhelming and cause market confusion.*

Your mind map may look like this:

You then want to set a revenue goal for each of these revenue streams.

If you have been in business for some time, you can use past sales to help you determine your revenue goals. If you are just starting out, you will have to consider your capacity and ability to make these sales. For example, if you run a graphic design studio, and brand identity kits are one of your revenue streams, you may wish to consider how many of these you can complete in a year and how much you would charge for each. You may decide that you can take on two per month (or twenty-four over the year). You will charge $3000 for each of these, so the revenue goal for this particular stream will be $72,000 (i.e. $3000 ×24).

Continuing with our example, where the Thrive figure is $100,000 and the revenue streams are online, wholesale, pop-up store and white label, the mind map may then look like this:

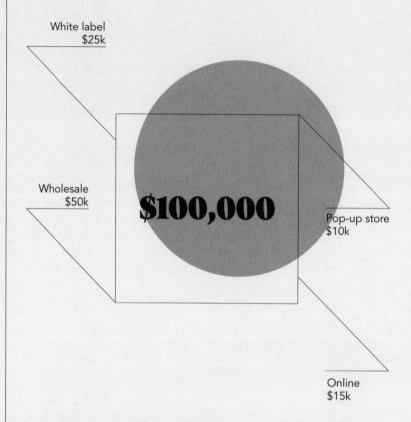

White label
$25k

Wholesale
$50k

$100,000

Pop-up store
$10k

Online
$15k

The total income from all revenue streams is equal to the Thrive figure in the middle. When completing this exercise, you may realise that your revenue streams do not equate to your Thrive figure. They may be well below, or way above. If they're below, you'll need to consider whether you're truly at capacity in each revenue stream, what else you might add or if there is a way to tweak a current revenue stream so that the revenue goal is higher. For example, say you currently offer one-on-one coaching. By shifting to group coaching, you can bring in a higher revenue. You could then change your one-on-one coaching to be a premium service that you offer at a much higher rate.

The next step is to consider the expenses you'll have per revenue stream and the percentage profit you will be left with for each.

For example, with the graphic design studio, you may have to pay for software licences for programs such as Illustrator or Photoshop. Likewise, you may choose to invest in a quality DSLR to take photos of elements for branding kits, or you may have to pay for a course platform, like Kajabi or Teachable, to sell your course. All of these are expenses that cut into the total revenue and your potential profit.

With our example of the product business that needs to bring in $100,000, expenses may include:

- Staff
- Public indemnity insurance
- Advertising
- Rent

- POS systems
- Bank fees
- Ecommerce store fees

The end profit percentage for each stream (after removing expenses) may look like this:

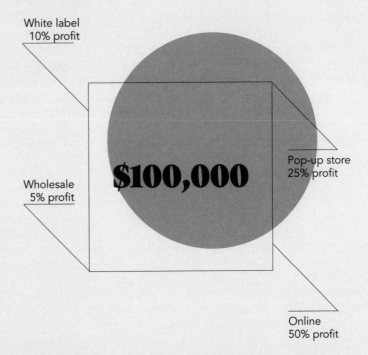

White label
10% profit

Wholesale
5% profit

$100,000

Pop-up store
25% profit

Online
50% profit

In this scenario, it may well be worthwhile focusing on online sales vs. wholesale due to the massive difference in profit margins. That said, the wholesale accounts may help build brand awareness, which will, in turn, drive online sales. Your choices will depend on your business goals, time in business and your overall business 'why'.

While this is not an in-depth financial exercise (and I'm by no means a financial advisor!), this exercise will begin to show you where the profitable revenue streams are and shine light on revenue streams you may have thought were working, when, in reality, they were just breaking even.

I had one client work through this exercise only to discover that she was barely meeting the expenses of most of her revenue streams, while completely ignoring another revenue stream that had the potential to be hugely profitable for her. Needless to say, we workshopped how she could shift to work predominantly on things that her audience wanted that also provided a healthy profit margin.

Look at the revenue streams you have identified and the expenses associated with each one. Then consider the profit that will remain.

Are there revenue streams you have been ignoring that are far more profitable than others?

Are there expenses you may be able to reduce or remove altogether?

Get really honest here. There's no point building a business that just breaks even. That, my friend, is a quick path to desperation, #hustle and burnout, and certainly not a business that will enable you to *Thrive*.

If you would like to gain further insight into profitability, I highly recommend Mike Michalowicz's book, Profit First, *which I use in my own business and suggest to clients.*

There's no point building a business that just breaks even.

Keep it coming

When it comes to mapping out your revenue streams, one area to consider is the opportunity for recurrent revenue.

What do I mean by recurrent revenue?

This is the revenue that is coming in on a regular basis, such as retainer clients for service-based businesses, or from subscription boxes for a product-based businesses. This can help immensely with calming the ad-hoc financial peaks and troughs many small business owners experience.

If you don't already have recurrent revenues in your biz, consider which of your revenue streams could become recurrent. Could you move away from offering one-off packages to offering six- or twelve-month packages with a monthly fee? Could you introduce a membership model? Could you introduce a subscription offer to your product business (e.g. monthly earrings, monthly workout gear, monthly socks)?

Partnerships can be a great way to add in recurrent revenue. For a product-based biz, this may be things like partnering with a hotel chain that will use (and constantly reorder) your skincare products for their bathrooms. For a service-based biz, this could be partnering with larger agencies, who frequently include your workshop or session within their larger pitch to clients, then charge a percentage on top of your fee to their client.

Review your revenue streams and look for recurrent revenue opportunities.

Believe in what you do

It's one thing to plan out how you will make money, and quite another to actually, well, make that money.

One question I like to ask my clients and students when it comes to *making* money is this:

Do you believe in what you sell?

Do you?

Do you honestly think it helps people?

Do you believe it improves your customers' lives?

If you don't believe in what your business offers, how will anyone else? How will they be moved to part with their hard-earned cash and invest in your offerings?

I am not ashamed to admit that I'm a *Real Housewives of Atlanta* devotee. My fave cast member? Kenya Moore. In case you (like my husband) have never watched the show, Kenya Moore is a larger-than-life woman who is known for her catchphrase, 'I'm fabulous, *I'm Gone with the Wind* fabulous.' (Look up the GIFs, they're hilarious.)

The reason I'm discussing Ms Moore is because when it comes to your business, you need to be its best sales agent. You need to channel your inner Kenya Moore and believe that what you are offering is *Gone with the Wind* fabulous.

Do you believe it? Are you telling people about it?

Are you regularly getting out there, initiating contact with your audience and letting them know what you do? Are you making it clear how they can work with, or purchase from, you?

I mentioned this previously when we discussed your inner marketing hater, but it's worth stating again: just because you have a great business and offer great products, that does not mean that people will find you. You need to go to them.

In the last chapter, you looked at the various channels and avenues you will use to *connect* with your audience, *cultivate* a community and *convert* people into brand advocates.

Now it's time to review those channels against your revenue streams and financial goals.

Are you out there, telling people why they should invest in what it is you offer?

Are you regularly using the appropriate marketing channels for each of your revenue streams? For example, as a leadership coach you may use a tool like LinkedIn and face-to-face networking for gaining $40,000+ project work, and a tool like Instagram for selling your $39 ebook (with an automated email sequence).

Could you tweak your current messaging to guide people from one revenue stream (e.g. online clothing sales) through to the next (e.g. one-on-one personalised style advice sessions)?

Are you regularly reviewing feedback from clients/customers in each revenue stream in order to improve and future-proof it? Are you helping people become advocates for that revenue stream by following up with post-purchase communication? (Remember the Buyer Cycle!)

Will you commit to validating your ideas for revenue streams with your ideal audience, prior to launching, so that you know that the price, position and promotion will work?

Are you getting in the way?

When you run your own business the buck, quite literally, stops with you. If you haven't been hitting your revenue stream goals or you think your Thrive figure is miles away, it's time to consider how YOU have prevented the business from gaining the financial traction it needs.

I can almost hear the wails. 'But I'm doing the best I can! It's not my fault we're not making money.' I hate to break it to you, but sometimes, my friend, it is.

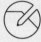 To work out how YOU are keeping the business from making what it needs, start by answering these questions (as honestly as you can):

- Do I really know my audience? Do I know their pains, their beliefs, their desires, their fears?

- Have I validated each revenue stream (the actual product/service and the price I'm charging)?

- Am I testing copy, ideas and marketing tactics to see which resonates most and converts people from the Evaluation stage to one of Purchase?

- Am I even asking for the sale? Am I showing people what I offer?

- Am I showing social proof (testimonials, reviews etc.)?

- Am I showing my experience and why they should buy from me?

- Have I crafted an attractive USP?

- Is it clear what I actually sell?

- Am I giving people too much choice?

- Am I not giving people enough choice?

- Am I nurturing the leads/contacts I already have?

- Am I showcasing elements that speak to their values?

- Am I clearly showing their problem and the solution my business offers?

- Am I talking about myself in my marketing or talking about them? (Hint: it should be more of the latter.)

The point here is not to play the blame game, but to look at mistakes you may have made when it comes to marketing and selling your revenue streams, and to consider the lessons these mistakes can teach you.

Let's revisit the Buyer Cycle. Look at this carefully.

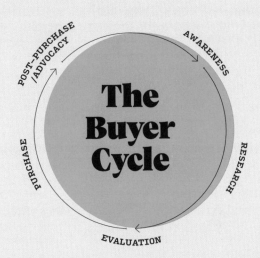

Where in the cycle are you walking away from potential revenue?

Where are you failing to nurture?

Where are you failing to provide enough information to lead people to the next stage?

Where are people dropping off?

Where and how are you consistently following up?

How are you selling?

The last question you need to consider when it comes to actually making the money is: how are you selling?

With features?

Or with benefits?

I'm as guilty as any other business owner of selling too often with a features-first mindset. That is, telling everyone ALLLLL the features of an offer and none of the benefits.

Consider the following marketing messages:

1. Our Levi Elio baby blankets are made from 100 per cent organic cotton.

2. Our Levi Elio baby blankets are made from 100 per cent organic cotton, which means they wash easily, dry quickly (oh hai #BusyMama) and are great for sensitive skin.

Which would entice you more to buy?

The first simply lists the features, i.e. organic cotton. The second shows the benefits.

For example, I've made the mistake of listing out things like 'almost 100 pages', 'DIY templates' or '6 × live coaching calls' rather than mentioning how people will benefit from this.

Rather than stating that it's 'almost 100 pages' when selling my ebook, I could say 'At almost 100 pages, you can rest assured you'll be able to stop googling the answer, get your time back and have the confidence that everything you need to do X is right there in one easy-to-access document.'

Likewise, instead of promoting the '6 × live coaching calls', I might say, 'You'll have the opportunity to discuss your challenges during coaching calls, where you will not only gain insights from me but also feel the support and encouraging energy from your fellow members who will be right there alongside you as you grow your business.'

Review the way you're currently selling, such as your product detail pages on an ecommerce site, or your pitch deck if you're a service-based business.

Are you stating only the features or are you also sharing the benefits?

Action

Phew! This has been a longgggg chapter. Getting your money right will be one of the most important things you can do in order to sidestep the #hustle and build a business you love. Take a few minutes to reflect on how you do/will make money for your small business.

Then answer the following questions in as much detail as you can.

1. What are the beliefs you have around money that may be hindering your ability to bring more of it into your business?

2. What does financial success mean to you?

3. What is your Survive figure?

4. What is your Thrive figure?

5. What are your revenue streams? Set a goal for each, then look at the expenses for each. Which are the most profitable?

6. Where is your recurrent revenue?

7. Do you really believe in what you sell? Are you your best sales agent?

8. How are you currently preventing money from flowing into your business?

9. Do you sell with benefits, not just features?

10. What needs to change in your business so that you can hit (or even exceed) your financial goals? (You may wish to refer to the work you did on your Start, Stop, Keep back in chapter 2.)

11. How and when will you track your revenue goals? Add these dates into your calendar and ensure you commit to them.

12. Which systems and processes might you need to set up to help with making money? (e.g. using new accounting software, setting up a common process for reporting, requesting payment up-front or adding late fees etc.)

Henrietta Thompson, *co-founder, Harth*

Henrietta Thompson is the co-founder of Harth, an innovative platform that connects design lovers with items they can rent for their home, office or commercial property. In addition to running the business with her husband, Ed Padmore, Henrietta is also an accomplished writer, editor (including Editor-at-Large of *Wallpaper*), curator, TV presenter, author (of five books!) and co-founder of Furthermore Media.

You have been involved in the creative scene, particularly design, for years, publishing books, writing, editing and appearing on various mediums and in globally respected publications. How did your upbringing influence your career choices? Is design something you grew up knowing a lot about?

There are lots of creative brains and mavericks I could cite as inspirations and mentors but, to be honest, I don't think I really understood what design was until I went to university to study it. Before that I knew I loved architecture and fashion and art, and art history, but mostly I wanted to get into publishing and magazines, or advertising – I remember being excited by the creativity going on in that sector too, but editorial won the day for me; it was a better personality fit I guess. Probably the likes of *Wallpaper* magazine and *Blueprint* were an early influence but, looking back, 'design' wasn't a thing as much as it is today. It was a smaller world and, as such, easier to get a foothold in it purely by dint of enthusiasm and networking (or going to lots of parties).

You launched Harth in 2018. The business may, to some, seem like a break away from discussing the latest trends and the beautiful furniture brands to purchase. What led you to start Harth and what is the 'why' behind it?

There's so much beautiful stuff in the world already and too much of it is hidden away in storage. Our problem, generally, is rarely not having enough stuff (the opposite!) but having the wrong sort. We just felt like there must be a better way. I've long been really interested in the changing face of consumerism, the sharing economy and also the idea that we are defined by what we own – that just doesn't seem to be a relevant concept anymore.

I also love the idea that things have a life, a story to tell, and modern technology allows us to do that. Things that are rented traditionally were always considered second rate, but that doesn't have to be the case anymore. If it has had a life, a patina, a history, that can potentially make it even more valuable. I want Harth to enable a new era for restoration, and encourage people to look after things better, with more respect.

Who is Harth aimed at? Who is your key audience/s?

So far we've focused on professional markets – property developers, stylists, pop-up shops, interior designers and so on. Our next phase is much more squarely aimed at consumers. That's where I believe we can make the biggest difference. We're not 'high end' or luxury so much as design led. There's lots that is very accessible on the platform – we just say it has to be made with integrity and designed to last/be loved.

The concept is new in the design industry, although it obviously speaks to the sharing economy (Airbnb etc.). Has it been harder or easier than you thought to get people on board with the concept? What have been the main objections and how have you overcome them?

As with any platform, we have two sides to consider: supply and demand. The supply side has been super quick to build;

both designers and brands are keen to rent their pieces, as are individuals. Harth seems to really speak to the problem we all understand: that of having too much stuff.

Borrowers are more cautious to come on board and we've been working really hard to make sure we can really address the barriers here: logistics, insurance, pricing etc. – these have been challenging but we're already seeing really encouraging results.

Photo © Kensington Leverne

What does the name Harth mean and how did you come up with that?

It doesn't mean anything; it sounds like 'hearth', which is warm and friendly and homely, but it's our own word, so we can use it as a verb too. It's also got 'art' in the centre, which we like.

You have been responsible for helping so many design brands get themselves out there throughout your career. How did you decide to launch Harth? Did you have a big plan for this or was it more organic using your own networks?

Harth has really had its own momentum. In many ways we didn't want to talk about it at all until it was perfect – which it's still very far from being. But then we just couldn't keep it a secret anymore because we were having so many conversations with brands and designers trying to build up the product on the platform and test it all out.

When the press got wind of it we were a bit overwhelmed, and worried too because it's important to manage expectations, and if people are visiting the site thinking they're going to find a very polished service, they might be disappointed. The chicken and the egg! The way I see it now is that we'll probably be celebrating lots of mini launches over time; it' will never be a finished thing.

You run Harth with your husband, Ed Padmore. What advice would you give to others wanting to start a business with their partner, family member or good friend?

Only you can know if it's something you'll enjoy. So many people tell us they could never work with their partner, but for us it's all happened quite organically. We can't help it! My advice? Communication and respect. And make sure it's not ALL work.

Where do you seek advice or mentorship when it comes to business?

Mostly from people I've worked with and who I admire, but I won't start mentioning names as we'll be here forever. I love podcasts but not really for business advice, more for current affairs and conversation and opinions. Ed is a big reader of business books, he always has about five on the go at any one time.

Have you had to hire people for Harth? If so, what has that process been like, and are there any lessons you can share to help other small business owners who may be hiring people for the first time?

We have, yes. And we've been really lucky on the whole, with only a couple of off decisions, and those people didn't stay long mostly because they didn't fit with the culture of a startup.

Our first hire was one of my oldest friends, and she became our Managing Director. She was amazing and we've only just lost her, two years later, because she's gone to set up her own business. Overall, it was brilliant though she'll be hard to replace!

The rest of the team are also now close friends. We have a very open and transparent culture – we have fun but we also work really hard. It has to be like that, I suppose, as there's a lot of uncertainty and hard graft involved in a small business and especially a startup of this nature. Personality is as important as ability.

Are there any mantras or quotes you come back to again and again, in relation to your business?

Only you know your business. Listen to everyone else, sure, but your gut should always win out.

Also, 'You get to this point where you could give up, but success is that moment when you don't.' Brianne Kimmel

I read this yesterday and LOVE it, because I relate so strongly to it this week as we've just opened our first pop-up. It's been an epic undertaking and we really nearly called it all off several times, but now we are here and in and it's such a great feeling.

What do you want Harth's legacy to be?

I really want to make people think differently about the way they consume, especially when it comes to furniture and art, to put less emphasis on ownership and more on enjoyment, the environment and creativity. My dream is that as people make this shift (across all areas of our lives, and not just with Harth), design will evolve too, and there will be a broader assumption that things should be made to last and be looked after.

harth.space

@harth_space

Photo © James Harris

Where will you be tomorrow?

PAGES 141–159

I am a child of the eighties and nineties, a time when microwave cooking was in its element, and making chip shrinkie toys in the oven was a favourite pastime (#RememberThose?).

In the early nineties, my mum came home from work with four white sheets of paper, each bearing a plate-sized circle – one each for myself and my three older siblings. Excitedly, she informed us that these pages were an art project. We could draw anything we liked within the circle, then they would be 'cooked' and turned into plates that we could keep forever. Mum got out a bunch of markers, paper and photos, and we all sat around thinking about the designs we would create. She encouraged us to think about what was important to us, and to immortalise it via our dinner plate designs.

I drew my dog Goldie, my cat Tiger, a peace sign, a picture of myself (weirdly with the haircut I have today but didn't have back then #Spooky) and a quote by American author William H Johnsen I had seen pinned up in my sister's room. The quote read: 'If it is to be, it is up to me.'

I still have that white plastic dinner plate. It's now one of my eldest son's favourites, and whenever he asks about my drawings, we always end up discussing that quote.

Too often as small biz owners, we can forget that we have control over the way things turn out. Sure, we may not be able to affect the weather or predict an algorithm change, but we can control, to a large degree, what our business achieves and how successfully we scale it.

In this chapter, we are going to look at what you most want to achieve when it comes to your business, what this will look like in the coming twelve months and how to narrow down your ideas to your three top goals. We will also look at habits – those daily actions that can really help us sidestep the #hustle and truly build a business we love.

If it is to be, it is up to me.

Start with the end in mind

I see so many small business owners spend a lot of time and money on preparing for their business – creating their visual brand identity, designing their website, getting business cards printed, choosing outfits and locations for their brand photoshoot. But I rarely see them taking the time to consider where they want their business to be this time next year, or even this time in five years.

One of the first questions I'll ask anyone who contacts me for business coaching is: What are the three things you most want to achieve in your business in the next twelve months? Which three things – if you accomplished them – would make you feel like the business was a 'success'?

"Which three things – if you accomplished them – would make you feel like the business was a 'success'?

While some people will roll out an answer, more often than not I'm met with silence, or an 'I don't actually know … I haven't really thought about it.'

It's as if we are driving a train and don't really know where we are headed, or even if we have enough fuel for the journey.

So far in this book we have discussed your 'why', where you are right now in your business, who you serve, your brand and how this is reflected in your marketing at all stages of the Buyer Cycle, and how you will make money. Now it's time to consider where you want to be tomorrow.

Where is your business headed?

Are you building this business up to sell it at some stage?

Are you building an empire that your children, and their children, can one day inherit?

Are you creating a business that, through its earnings, will enable you to give back by opening schools or health centres in impoverished parts of the world?

Are you creating a new way of doing something that will benefit the planet for generations to come?

Are you scaling your business so that you can retire early and spend time travelling the globe?

Are you building a business that will mean you never have to work for someone else again?

Where will your business be tomorrow?

Where will your business be twelve months from now?

At the start of this book I discussed mapping out my life one year from now, and how the results of that exercise were the final straw that helped me get out of corporate life and build the business I wanted to.

Now it's your turn.

Creating Your Awesome Year (#YAY)

Deciding what you want can be hard. Using a visualisation exercise is a great way to consider what it is you *most* want for, and from, your business.

How do you do this?

Take a few minutes to write down the date one year from now. For example, if it's 30 September 2021 today, then you would write down 30 September 2022.

Then, imagine you are looking back on the twelve months in your business that have just passed.

What did your year look like?

What was the best thing you achieved?

Did your website get loads of traffic?

Did you become completely carbon-free?

Did you launch an ecourse?

Did you get on international morning TV?

Did you get mentioned by X media?

Did you win any industry awards?

Did you write a book?

Did you open another store?

Did you hire more staff?

Did you speak at X conference?

Did you launch live workshops?

Did you get on X podcast or radio show?

Did you have more time with family?

Did you run a marathon?

Did you build a genuinely diverse team?

 Look at your twelve-month plan on the opposite page and input these imagined scenarios.

(You will have to start by inputting the month and year for each of the twelve boxes – each one represents one month in the coming year.)

These should be stretch goals, but not completely OTT, like becoming BFFs with Beyoncé (although hey, maybe that can still happen for me #KeepHopeAlive).

Your Awesome Year – at a glance

MONTH, YEAR			

It's important to factor in any personal goals that will impact on the time you have to spend on your business. An event like a marathon may mean you have less time in the business in the months prior, as you may ramp up your training. Likewise, a family holiday may mean you're unavailable for media or podcast interviews during that time.

If you have a team, you may wish to ask them to do this too, either individually or as a group exercise. It's always interesting to see the different 'priorities' that surface.

Lastly, add to this any key dates you already know of, such as trade shows, holidays or important industry dates that may impact business operations.

Here's an example of what your calendar might looked like:

MAY 2021	JUNE 2021	JULY 2021	AUGUST 2021
International media hit × 1	EOFY event	International media hit × 1	MOVE INTO NEW STUDIO SPACE
Hire VA	Launch vlog series		
Mandy on AL last two weeks	WEBSITE LAUNCHED	VA MOVES TO FULL TIME	Vlog × 4 per month
Website revised			Shoot in Bali
Brand photoshoot		Vlog × 4 per month	
		Hit 6k email subs	
	FIGUREHEAD MARKETING CAMPAIGN		

SEPTEMBER 2021	OCTOBER 2021	NOVEMBER 2021	DECEMBER 2021
International media hit × 5 (UK, US)	Pop-up VIP launch dinner	Vlog × 4 per month	Take December completely off!
FASHION WEEK EVENT	LAUNCH 2-WEEK POP-UP ($100K)	Finalise UNICEF collab.	Vlog × 4 per month
		Hit 10k email subs	
Vlog × 4 per month	Gifting season commences	HIRE FT ASSISTANT (IN-HOUSE)	Holiday event new studio
	Vlog × 4 per month		
FIGUREHEAD MARKETING CAMPAIGN			

JANUARY 2022	FEBRUARY 2022	MARCH 2022	APRIL 2022
Vlog × 4 per month	International media collaboration	IWD EVENT	Vlog × 4 per month
UNICEF photoshoot	Vlog × 4 per month	Vlog × 4 per month	Shoot in Bali
	COLLABORATION WITH UNICEF	Hit 14k email subs	HIT $800K (55% PROFIT)
			Hit 15k email subs
WOMEN IN CREATIVITY CAMPAIGN (IWD EVENT)			

The Power of Three

Now that you have mapped out a rough calendar for Your Awesome Year, it's time to get specific.

When it comes to setting business goals, one of the most common mistakes I see people make is to set too many. I'm as guilty as anyone else of getting sidetracked by every shiny new object and adding a whole bunch of I-could-do-that-too!s to my list. All that does is dilute your focus and leave you with the feeling that you 'hustled hard' but didn't actually achieve very much.

Remember in chapter 2 when you set benchmarks for where you are right now as a business owner and wrote down one or two sentences stating what you most need to focus on to get there? The reason I asked you to write just one or two sentences was because it forced you to focus on what was most important, not waffle on about #AllTheThings.

Take a look at the Awesome Year you have just mapped out. Does it align with your 'why', and the sentences you wrote at the beginning of this book?

Out of all of the fabulous achievements you have included for the next twelve months, which are the top three? The ones that make you feel like you're building a business you love? While they may involve hard work, they shouldn't make you feel that you'll be forced into hustle territory.

Which are the things that light you up and get you excited?

Which are the things that you know will help you connect with your audience while also helping your business achieve its Thrive figure?

What are the top three goals you want to achieve in the next twelve months?

What are the top three goals you want to achieve two years from now?

What are the top three goals you want to achieve three years from now?

Having trouble narrowing it down?

Here are some tactics that may help you narrow it down to just three:

1. If I'm faced with too many ideas, a question I like to ask is, how would I feel is this did *not* happen? Would I be incredibly disappointed or would I be okay? By asking myself that, I can usually weed out the maybes from the must-dos.

 In 2016 I bought an intro track for a podcast I wanted to launch. I spent time writing out podcast topics and coming up with a list of people I would interview. 2016 passed without me launching my podcast. So did 2017 and 2018. It was only in 2019 that I finally decided that launching a podcast was an important enough goal that I would do it.

2. If you're finding it hard to narrow down your choices, another point to consider is whether something can become a sub-goal. For example, my podcast in 2019 was a sub-goal under the goal of building my email subscriber list to X. You may have various items that could sit under one umbrella goal. *(While this can help, it's also important not to just move everything into a sub-goal or you defeat the entire purpose of narrowing down.)*

3. Lastly, consider your goals in terms of money, marketing and mindset. After working with hundreds of small biz owners, I can confidently say that almost all goals can be divided into three camps:

 If you're getting stuck narrowing your goals down to just three, placing your ideas under the themes of Money, Marketing and Mindset may help.

Money How much do you want the business to bring in? You have already worked out your Thrive number, but through the course of this book you may have decided to add or subtract money-making activities. Perhaps one of your three goals will focus on money.

Marketing What do you want your marketing to do for your business? Do you want to be able to confidently market your business? Have systems and processes set up so marketing is done automatically? Do you want to get to X per cent conversion rate or X subscribers?

Mindset This is where I hear a lot of goals along the lines of 'less stress', 'higher levels of engagement', 'a fantastic company culture' or 'being excited about Mondays'. What would sidestepping the hustle feel like for you? How do you want to feel one year from now?

When it comes to goals, you want to get as specific as you can.

Get specific

In chapter 6 I mentioned my experience with a mortgage broker. During our initial conversation with him, we discovered that our deposit (which we thought was fantastic and totally where it needed to be) was short, by approximately $18,000. If we wanted to buy a house by mid 2015, we needed to find another $18,000 cash. Having a specific amount and a deadline (June 2015) gave us the structure we needed to achieve this.

Similarly, when it comes to goals, you want to get as specific as you can.

'Make more money' is not as specific as 'I want to move from the business making a total revenue of $400,000 in June 2021 to making $700,000 by June 2022. The reason I want to do this is to be able to hire more people and have a greater impact on the world through donating a portion to charity X.'

'Growing my team' is not as specific as 'I want to increase our team from myself and a virtual assistant as of June 2021 to myself, a full-time marketing manager, virtual assistant and a part-time sales manager as of June 2022. The reason I want to do this is that it will allow me to step back from the day-to-day and focus on activities that will really grow the business.'

Getting specific enables you to narrow down exactly what you want and when you want it.

A good formula for this is: I want to move from [situation now] in [date] to [situation when goal is achieved] by [date]. The reason I want to do this is [state why achieving this goal matters to you].

Look at your goals. Can you use this formula to get more specific and add in your reasons behind each goal?

Let's talk about habits

As I said in the introduction to this book:

Nothing changes if nothing changes.

Writing down your goals is one thing. Achieving them is something else entirely. While we will dive into how to get – not just set – goals in the next chapter, at this point it's worth looking at any habits you have that will help, or hinder, you in achieving your business goals.

A habit is something we do almost without thinking. It's a routine of behaviour that we perform so often that it becomes second nature. Think brushing your teeth, putting on your seatbelt or making coffee first thing in the morning.

Every small business owner will have habits that help and habits that hinder their success.

What are *your* habits?

How will these impact the three goals that you have determined are key to your success in the next twelve months, and beyond?

How might you go about changing these habits so they help, rather than hinder, your business success?

Some common habits that can *hinder* your success as a small biz owner include:

- Scrolling social media instead of working.
- Comparing ourselves to others.
- Not asking for help when it's required.
- Leaving things to the last minute.
- Avoiding difficult conversations.
- Failing to delegate.
- Not setting boundaries.
- Underpricing for fear of missing out on a sale/client.
- Selling with features only.
- Investing in education, but not implementing any of it.

Some common habits that can *help* your success as a small biz owner include:

- Time blocking your week.
- Checking emails at specific hours of the day.
- Delegating/getting external help.
- Limiting time spent on social media (a tool like tomato-timer.com is great for this, as is the alarm on your phone).
- Selling with benefits.
- Asking for help.
- Doing one thing every day that scares you (such as sending an email to a potential collaborator, or pitching yourself for a podcast).
- Batching content.
- Implementing any education you gain.
- Templating processes.
- Prioritising time for face-to-face connections with staff.

Examples I have implemented in my own business include:

HINDER HABITS	HELPFUL HABITS
Keeping phone in bedroom and checking it first/last thing.	Keeping phone in kitchen overnight and only checking it once I have considered my key actions for the day.
Answering emails at any hour of the day/night.	Answering emails at set hours of the day.
Having no boundaries with clients.	Setting boundaries with clients.
Working on various activities each day.	Time blocking my work week so I'm focused on only 1–2 activities per day.
Typing lengthy emails in response to client questions.	Using voice messages to answer ad-hoc questions from clients.
Getting distracted with education any time of day/night.	Setting scheduled education time 8–11 pm Wednesdays.
Accepting payment any time it suited the client.	Requesting upfront payment for all work.
Trying to do it all myself.	Hiring a virtual assistant, graphic designer and web developer.

What might *you* change when it comes to your habits?

Action

Take a few minutes to reflect on where you want your business to be one, two and three years from now.

 Then answer the following questions in as much detail as you can.

1. Where is your business going? Where do you see it in the future?

2. What would an Awesome Year look like for you?

3. What are the three things you most want to achieve in your business by this time next year? Which three things – if you achieved them – would make you feel like the business was a 'success'?

4. Which three things would you like the business to have achieved in two years? And then in three years? Why are these things important to you?

5. How can you get more specific when it comes to your goals? Why do these goals matter to you?

6. What are your habits? How will these impact the goals you have determined are key to your success in the next twelve months, and beyond? How might you go about changing these habits so they help, rather than hinder, your business success? You may wish to use the table on the opposite page.

HINDER HABITS	HELPFUL HABITS

Ali Kamaruddin,
founder, Forty Thieves Barbershop

Ali Kamaruddin is the founder behind the thriving Forty Thieves Barbershop in Mount Maunganui, New Zealand. An avid traveller, Kamaruddin left his native Malaysia to explore the world, spending time in England, India, Indonesia and New Zealand before settling in the latter almost a decade ago. In 2017, he set up Forty Thieves, which allows him to indulge his love of surfing alongside running a small biz that's become a welcoming hub for its coastal community.

How did your upbringing shape your business? Did your parents run their own businesses?

My dad is a paediatrician and my mum was a nursing tutor. If anything, they had hoped one of us would be in medicine. But none of my siblings are. Later in life my parents opened two restaurants back in Kuala Lumpur, but I was never really a part of it. Owning a small business was never really a conscious decision per se. It was more like: I have this skill, I love doing it, how do I share it with other people and still make it work for me?

What is the 'why' behind your business?

I have a very laid-back attitude towards life in general and I think that influence comes from surfing. I try not to sweat the small stuff and I don't take myself too seriously. I think the shop is a reflection of that – just a cool place for people to hang out and have fun. :)

Can you tell us about the mix of business offerings at Forty Thieves and how you came up with those?

Essentially, Forty Thieves is a barbershop. But when I created the identity, I wanted it to be a brand that is versatile, so that we can expand to different things in the future. A lot of people underestimate the power of good branding: to some, it's just a logo. But to me, it's more than that – it's the tone you set for your business to the masses. When you have a good brand backed by a good culture, you'll get a good following – and for us, all the other business offerings were a response to that. I feel the future is limitless for the Forty Thieves brand.

You have created and built a business in New Zealand, a country that you didn't grow up in. What was this journey like?

The biggest hurdle was not having any family support. I certainly took that for granted when I was living back in Malaysia. I couldn't just swing by my mum's for lunch and get her two cents. I also could not fall back on my family if things didn't work out. I had to make it work, there was no other option. In contrast, it is surprisingly a lot easier to set up a business here in New Zealand as opposed to Malaysia. Malaysia has a lot of unnecessary red tape.

Another big hurdle I knew I would face was financial management. I am *clueless* when it comes to money. It was *imperative* that I found an accountant that I could trust. I consider the one I have right now a superstar, and she is part of the Forty Thieves family. We would be so lost without her.

Photo © Kensuke Saito

It was more like: I have this skill, I love doing it, how do I share it with other people and still make it work for me?

Did you work with anyone else on the launch and branding of the business? If so, how did you decide who to work with? What characteristics were you looking for?

It was important to me that I worked with people who knew me very well when it came to setting up the brand. This was to ensure that I could keep communication breakdown to a minimum. I'm fortunate that in my job I get connected with all sorts of people, including talented art directors. The team I worked with have been getting haircuts from me for ages and we've always talked about creating the brand when the time was right. I consider them my friends, and we often discuss concepts out in the water when I see them out for a surf. So when their first proposal came, I said 'yes' straight away.

Your love of surfing is present within your business. Many small business owners get stuck in a role of work work work. How have you been able to run a business while also having time to indulge in your passions, like surfing?

Here's the thing: I am passionate about surfing, I am passionate about barbering and I'm passionate about the area I live in. So the formula was already there, I just had to piece it together and follow through. Hard work is inevitable when you run your own business because no one else is going to care more about your brand than you. But I've been lucky enough to be able to roll all my passions into one; it hardly ever feels like work. That's a good recipe to start with.

Where do you seek advice or mentorship when it comes to business?

My main source of advice comes from my clients. A lot of them run their own businesses in the area – from mobility scooters to restaurants to clothing, and some have been around for a long time. They always help me out with whatever they can, giving me tips on managing taxes, who to talk to for what, what to expect in the first couple of years. Sometimes it's even just lending a sympathetic ear when I'm frustrated.

Have you had to hire people for Forty Thieves? If so, what has that process been like, and are there any lessons you can share to help other small business owners who may be hiring people for the first time?

I have no full-time employees in the barbershop. All the barbers are contractors that just pay me daily rent. I deliberately structured it this way because I don't want to be anyone's boss. It keeps the energy creative, they take pride in their own work and they have more flexibility. I would say to establish what you expect out of the people who work with or for you. Do you share the same goals? Do they fit in with your brand? Are they driven and motivated? Do they have a positive attitude? You can pretty much determine this from having a conversation with them.

Are there any mantras or quotes you come back to again and again, in relation to your business?

I don't, but I have beliefs. I believe that you should turn something you're passionate about into a business, otherwise you will end up hating it and not giving it a hundred per cent. Once you've established that, I believe that hard work and perseverance pay off. Trust me.

What do you want Forty Thieves' legacy to be?

I'd like for Forty Thieves to be an establishment. That if you're in Mount Maunganui, you only want to get your hair cut at Forty Thieves. I want it to be a brand that is a part of the community and a part of their lives … because there is something so rewarding about watching some of your clients grow. I want for people to always remember it as a cool place to hang out and have fun. If you're having a bad day, just come to the barbershop. :)

fortythievesbarbershop.com

@fortythievesbarbershop

Photo © Kensuke Saito

How will you get there?

PAGES 161–173

I'm not backwards in coming forwards.

Back in November 2006, a whole *two months* into my relationship with my boyfriend (now my husband), I informed him that if we were going to 'last', he would have to move from Melbourne to London with me.

I've spoken before about my first stint living in London in 2001, which ran for just over a year. I came back in late 2002, following the tragic death of a close friend, but I had always promised myself I would get back there. In August 2009, I took the plunge with my husband and boarded another one-way flight to the UK.

For almost two years prior to that flight I had been working for myself, running a small copywriting and branded content agency, as well as ghostwriting books that my husband would design. Despite being older than the first time I lived in London, I had the same heavy dose of naivety. I'd been successful in my work in Australia, so I was convinced my husband and I would simply scoot over to the UK, set up our branded content agency and be flooded with clients.

That dream couldn't have been further from the reality.

We arrived in the UK just as it was beginning to recover from the Global Financial Crisis. The few available jobs went to people with years of UK experience. After a few weeks freelancing and working with clients back in Australia, I knew the time had come to get myself a job. The Aussie dollar was worth less than half a British pound, and a hefty dose of London summer fun coupled with the costs of relocating had us chewing through our savings.

I sat down and considered my goal.

Goal: To. Get. A. Job.

I then wrote a list of the twelve things that would help me achieve this goal, starting with gaining employment and working backwards.

The list looked like this:

1. Research the types of roles I'd like to apply for (understand the terminology, titles, any differences between AU and UK).

2. Write my CV and update my LinkedIn profile.

3. Collate examples and testimonials of my work to date.

4. Create a template cover letter (tweak per role).

5. Email and ask networks for any leads or contacts in the UK.

6. Apply for roles.

7. Follow up applications.

8. Land initial interview.

9. Prepare for interview and complete.

10. Score final interview.

11. Role-play final interview with husband/ friends (practise, practise, practise).

12. Gain employment! #WootWoot.

Adding to this #NotSoFun time was the fact that our London apartment had no internet. For five weeks, my husband and I would trek down to Cafe 1001 in nearby Brick Lane, purchase two large coffees and use their free wi-fi to apply for jobs. We would only leave (usually around lunchtime) when our laptops needed to be charged. We would purchase a couple of 20p bagels on the way home and have them with cream cheese, spinach and cheap ham upon our return to the flat. Once our laptops had fully charged, we would head off again for the second coffee of the day and another afternoon of applying for jobs.

In that five weeks, I applied for more than 300 roles. I had nineteen interviews, and in seventeen of those cases I got through to the final round. But every single time I was told 'Sorry Fiona, it was close, but we have decided to go with someone who has years of UK experience.'

To say I was gutted was an understatement, but I knew 'if it was to be, it was up to me'. No-one was going to just hand me a job on a platter. I may have had a weekly column in the top newspaper in Australia, but in London I was a complete unknown.

I had to put in the work to make my goal a reality.

After what seemed like eons, I was offered a job at Open University UK, working on audience engagement for their online MBA program. Despite a lengthy commute (oh hai 6.43 am train from Euston!), I finally had a job.

Goal? Tick.

As Mark Twain said, 'The secret to getting ahead is getting started.'

I could have moped around my flat, bemoaning the fact that I had left a successful business in Australia and was now jobless in London. Instead, I got started on making my goal a reality.

For many small biz owners, the act of goal setting can seem like enough. *I've stated what I want to achieve, the universe should hear me, right? I'll just park myself here, at Manifestation Station and wait for the train carrying all of my completed goals to arrive.*

Setting goals is one thing. *Getting* goals is something else altogether.

In this chapter, we are going to look at how to achieve the goals you set in chapter 7. This is where you will get specific about what you need to action on a daily, weekly, monthly and quarterly basis to move from idea to execution. This is one of the most important chapters you will read, but ONLY if you actually complete the actions for your goals and put in the effort to make them happen.

> *Setting goals is one thing. **Getting goals is something else altogether.***

Start by getting curious

What would it take for you to achieve your goals?

When I am working with a new client, I have them fill in a questionnaire prior to our first session. This not only gives me insights into their business, it also forces *them* to get curious about what it might take to achieve their goals.

The questionnaire asks them for five ways that they – without any help from me – could close the gap between where they are now and where they wish to be.

Often we know the answer, but we don't take the time to ask the question.

The problem with goal setting is that it ends when you have written down the goal. Goal *getting* starts by getting curious about how that goal will be achieved.

Socrates said, 'Wonder is the beginning of wisdom.' If you have ever watched a child complete a maze in a workbook, you will have seen them stop, pause and give themselves the space (even a few seconds) to wonder how they will tackle the exercise.

That same wonder is often missing from small biz owners, as they choose stress and fear over curiosity.

Instead of thinking, *this is just way too hard*, consider an alternative: *how might I achieve this goal?*

The first – and, I've found, the easiest – place to start (and the same place a child would start with a maze) is with the end in mind. Then you work back. When I created the top twelve tasks I had to do to get a job, I started with number twelve: Gain employment.

What would the step before that be?

Possibly completing a second/final interview.

And what about the step before that?

Practising what I'd say in that interview with my husband or a trusted friend.

What would the step before that be?

Scoring an initial interview.

And so on.

Look at the three goals you have set. Can you think of the one action that needs to be completed just prior to each goal being achieved?

Now, can you think of one step prior to that?

And then one step prior to that?

If you're having trouble coming up with steps, consider chatting to someone, or researching stories from business owners who have done what you're looking to do. How did they start? Which tasks did they complete to reach their goal?

Depending on your business size and your goals, you may create a top twelve tasks list and realise that some elements on your list require their own top twelve tasks. An example of this is below:

GOAL: LAUNCH A PODCAST	SUB-GOAL: RECORD INTERVIEWS
1. Come up with podcast idea.	1. Create ideal list – twenty people.
2. Think of twenty episode ideas.	2. Research them.
3. Research equipment.	3. Create draft request email template.
4. Set up podcast studio/area.	4. Find email addresses.
5. Research RF music for intro track.	5. Send initial request.
6. Create intro script & record intro.	6. Follow up.
7. Record interviews/episodes.	7. Schedule interview time.
8. Find an editor.	8. Send questions so they can prep.
9. Create templates for show notes etc.	9. Collate marketing materials (photos etc.).
10. Learn about the back-end for uploading.	10. Record interview.
11. Publish podcast.	11. Send interview for editing.
12. Amplify launch.	12. Send thank you email and info for them to share when live.

Remember, goal getting is all about taking action to make it happen. It's also about staying focused. You don't need to overthink things. Don't create so many top twelve task lists that you get overwhelmed and forget the main things you're trying to achieve. I suggest you start your top twelve tasks list for each goal with the basics that will build momentum and, once achieved, will have you that bit closer to getting your goal.

Take a look at yourself

Getting curious doesn't stop at listing the practical steps you need to take to achieve your goals. It also applies to looking at yourself, as the business owner.

Who do you need to *be* to achieve these goals?

Back in chapter 2, we looked at your personality type, which may have shed some light on your strengths and weaknesses when it comes to the way you lead your business. Then, in chapter 7, we identified the habits that help – and those that hinder – your ability to succeed.

Now it's time to go even deeper.

Look at the goals you most want to achieve for your small business. Then take a look at the top twelve tasks you have listed for each goal (and for any sub-goals).

Who can YOU commit to becoming in order to achieve your business goals?

For example, let's say one of your business goals is to hit $1,000,000 in total revenue. To date, your business has been bringing in $450,000. You may have some limiting beliefs that keep you thinking your business can only ever make $450,000, or perhaps $500,000 max. How will you need to tweak your thinking to become someone whose business brings in $1,000,000?

In chapter 6, we discussed your money mindset. Your revenue goal may require you to revisit this in order to achieve your goal.

Likewise, you may have a goal that's focused on growing your team. Are you someone who likes to control every little thing (oh hai #MicroManager)? Will you be able to become someone who is happy to delegate? Can you hire with confidence and allow your staff to truly own parts of your business? How does that *feel* to you?

This step is about being really honest with yourself and identifying the areas you will need to tweak in order to become the person whose business can, and will, achieve its goals.

Make the time

Now that you have an idea of the top twelve tasks you need to hit to achieve your goals (and potentially those to achieve your sub-goals as well) and who you need to be in order to do this, it's time to schedule.

Back in chapter 7, we looked at getting specific and mapping out your twelve-month at a glance Awesome Year.

Now you're going to get even more specific and schedule deadlines for each of your top twelve tasks.

When will you take action on these tasks?

Is there any work you need to do before starting? If so, when can you schedule this in?

How will you stay accountable?

When will you track your goal progress?

What will you need to do daily, weekly, monthly and quarterly to achieve these goals?

What do the next ninety days look like for someone who is achieving these goals?

Are there any habits you can start that will help you achieve these goals? For example, if you feel you're bad at delegating, start practising this in your work and personal life. Start saying 'no' or asking for help. See how that feels.

Review your work

Now, I'm no John Edward – I can't predict when or how your business goals will be achieved. But one thing I do know, after almost twenty years working in senior content and marketing roles, is that marketing can help you accomplish your business goals, particularly those that are related to revenue, brand loyalty and even growing a team.

Before you get stuck into the actions for this chapter, it's time to review the work you have done on your 'why', audience, brand and marketing, and consider how this may impact your goal *getting*.

Go back through your answers and review the work you have completed on your marketing and brand. Do you need to make any tweaks to your goals, top twelve tasks or sub-goals to ensure true alignment?

Likewise, review the work you have completed on your revenue streams and money mapping. Do your goals align with how your business will make money?

Action

Take a few minutes to reflect on what you need to be doing in order to get – not just set – your business goals.

 Then answer the following questions in as much detail as you can.

1. What would it take for you to achieve your goals?

2. What are the top twelve tasks you need to complete for each of your goals (and, if necessary, your sub-goals)?

3. Who do you need to be in order to achieve these goals? What changes do you need to make in yourself?

4. What will you need to do daily, weekly, monthly and quarterly to achieve these goals?

5. What do the next ninety days look like for someone who is achieving their goals?

6. Are there any habits you can establish that will help you achieve these goals?

7. Review the work you have completed on your 'why', audience, brand, marketing and money. Do you need to make any tweaks to your goals, top twelve tasks or sub-goals to ensure true alignment?

8. Consider how you want to feel three years from now. Do your goals align with that?

Lucy Feagins, *founder, The Design Files*

Lucy Feagins is the founder of The Design Files, one of the world's most popular design blogs. Created in 2008 as a space for Lucy to document good design, it has grown to become a go-to for everything from articles on interior design and architecture through to interviews with creative families, small business owners and artists. In addition to the incredibly popular blog, The Design Files business incorporates events, the TDF Talks podcast, regular Open Houses, product collaboration and an art gallery.

When, how and why did you start The Design Files (TDF)?

It's so strange to remember the person I was when I first started this business! It was 2008, I was twenty-seven, and I was working as a set dresser and stylist in the film industry. I guess, looking back, I just wasn't very fulfilled in my career, and The Design Files started as a fun side project. I started it because, at that time, 'design blogs' were having a huge moment overseas, and I was reading a lot of international blogs and websites like Design Sponge, Dezeen, Moco Loco and Apartment Therapy. This was WAY before social media took off, and these blogs felt like a really rich, inspiring online community – I would liken it to the 'early' days of Instagram. It just felt like there was a real buzz around design blogs, and I really felt like Australia didn't have anything like that. So I just started one.

How long were you doing this before you thought it could become a business?

When I first started TDF I never intended for it to become a business, but about eighteen months in it seemed clear that there was an appetite for advertising. *Mind you*, this was 2010 – still a *long* time before 'native content', influencer marketing and 'brand collaborations' as we know them now.

Online publishing was so straightforward back then!

It was a conscious decision to start accepting advertising, but it still felt very much like a little bit of extra money on the side of my actual job. It wasn't until I decided to quit my job and focus on TDF full-time that I really started treating it like a business.

You were in the online/blogging space before it was even a 'thing'. At that time, where did you seek information that would help you build this platform?

There wasn't really much of a precedent for turning a blog into a business here in Australia, so I actually emailed some international bloggers early on, to ask their advice about hosting platforms and things like that. At the time, everyone was on Blogger/Blogspot, so that's where I started. But a few years in, WordPress really became the platform to be on, so I switched over.

I've always been pretty confident in the editorial and creative vision for TDF (rightly or wrongly!), but the technical side is definitely my blind spot, and it's where I've always sought professional help. I've been lucky enough to work with some super clever and really supportive web developers over the twelve years. I value their support

Photo © Amelia Stanwix

so much, I couldn't have built TDF into what it is without having such strong relationships with my web developers. They respond to any text, any time … which really is above and beyond the call of duty! But as a small business, who can't afford to have tech support in-house, I really, really value that.

How long did it take you between starting TDF and it bringing in enough revenue that you could completely quit your day job?

At eighteen months it started to bring in some money, and at about two-and-a-half years I quit my day job. Slow and steady!

Who else was involved in TDF in the beginning, and how did you finance bringing them on board? Did you get any sort of initial investment, other than advertisers?

TDF is a fully 'bootstrapped' business! We have no investors, and we have no debt. We're a cash positive business. All of our growth has been incremental. Each year, as we can afford it, we might hire another person or invest in a new thing. Being bootstrapped does have its challenges though. Mainly, it has meant slow and steady growth, not overnight success. But I'm okay with that.

I was very nervous to hire my first employee for this reason, and I am always nervous about expanding my team, because I'm very cautious about managing cash flow. But as we've grown, we've been able to extend our team and our output.

The people who work at TDF are an incredibly talented bunch – as well as just lovely people. Can you talk us through your hiring process and what sorts of things you have implemented internally to retain such great talent? What advice would you give to others?

As with everything else in this business, building a team has been very much intuitive. I've never worked in a big organisation, so I literally make everything up as I go along – and hiring people is no different!

My hiring process ideally starts at least three months before we actually need the person to commence. I write a job description and advertise the new role on our Instagram, and on LinkedIn or, if it's a design role, we might also advertise on The Loop. Although generally I find it's best not to cast the net too wide – we received 250 applications last time we advertised, which is a lot to manage.

From there, I look at all the applications, make shortlists, and I might send a task for people to do (if it's a writing or design role). I try to interview no more than five to seven people in person. I handle the whole hiring process myself, without the support of the team, so it's always a huge task, and I also want to respect each applicant's time and not waste it if they're not the right fit. (On that note, I always write a personal email back to everyone who has applied, letting them know if they're unsuccessful. Sure, there's often a bit of 'cut and paste' in there, but I really think it's important to respect people who have worked hard on a job application and expressed an interest in working for your company.)

Once the interviews start, that's where it's really about personality fit for me. By the time someone is at interview stage, you know they have the skills, it's about whether they have the right energy, and whether you can see them connecting with the rest of the team.

My advice to others hiring staff would be to pay attention to your gut feeling about each applicant. Skills can be taught, but good energy, work ethic, having a positive attitude and being a team player can't be taught. You need to find someone who comes to the table with all of that, especially in small business.

Are there any mantras or quotes you come back to again and again, in relation to your business?

I used to have this quote on a Post-it note on my computer screen, it's a bit of a weird

one but it stuck with me: 'People want to see you grow – deploy, deploy, deploy.'

What do you want The Design Files' legacy to be?

That's a BIG one!

In 2019 we ran a hugely successful crowdfunding campaign to enable Heide Museum of Modern Art to acquire a significant portion of artist Mirka Mora's estate, and essentially save it from going to public auction. We raised $200,000 in a week, which just blows my mind. I thought we might raise $30k, but our *amazing* community fully backed us. It was such a wonderful outcome and it felt so good

to use our influence in this way. It got me thinking about what people will remember about The Design Files in many years to come, and I realised that what we do day to day, as an online publisher, is so fleeting, and we have to create more opportunities like that – to give back and to contribute to something bigger and longer lasting.

I do have some more ideas up my sleeve, to leverage our incredible audience, and hopefully use our voice and our influence to do some more good in this world. Watch this space!

thedesignfiles.net

 @thedesignfiles

Photo © Amelia Stanwix

My advice to others hiring staff would be to pay attention to your gut feeling about each applicant. Skills can be taught, but good energy, work ethic, having a positive attitude and being a team player can't be taught.

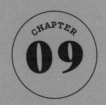

CHAPTER

09

Who else do you need?

PAGES 175–191

Do you remember what you ate for lunch Thursday 3 September 2015?

I do.

A falafel salad with feta, chickpeas and balsamic dressing.

The reason I recall this had nothing to do with food and everything to do with the company.

No business is an island. The most successful business owners I know are those who surround themselves with people they can learn from.

On that day, I had made the decision to leave my well-paid exec role, but I hadn't quite made the move to resign. I had asked a friend of mine, Chriss, to meet me at a cafe for lunch. Having run a successful PR and communications agency for years in Australia while also being a hands-on mum to two young children, I knew Chriss would have some insights into how I could make this work.

I wasn't wrong. During our forty-minute meeting, Chriss offered several tips and tactics, things I wouldn't have even thought to consider. From which accounting software I should use (her words 'Start as you mean to go on, invest in the best' still ring true) through to how much I could be charging and how to tier my approach, she allowed me to see my ideas as far more than just that. She helped me see what was possible and gave me tips on how to transform those ideas into reality.

I'm still good friends with Chriss, and I still chat with her when I have a business problem. Likewise, I have been able to help her with business issues at times, and we have even ended up working together on a few projects.

People really are your best asset.

Even if you're a solo operator and have no plans to ever hire anyone else to work in your biz, it's important to surround yourself with people who can help you thrive.

In this chapter, we're going to look at the different groups of people I believe every small biz owner needs to cultivate. We will also look at the importance of accountability, and at the need to have regular catch-ups with people who have *nothing* to do with your business.

If you have been in business for some time, this chapter will remind you to strengthen those networks and make time for regular catch-ups. If you're yet to start a business, this chapter will be one of the most important as you look at your own networks for support and encouragement.

Staying accountable

Have you ever started watching a new series on Netflix and silently promised yourself you'll only watch one episode, only to find that three hours and five episodes later you're still watching? #guilty

As hard as it can be to admit it, we break promises to ourselves *all* the time. But when it comes to making promises to other people, we often try a whole lot harder to show up and stay true to our word.

Whether it's because we don't want to let someone else down or because we don't want to be thought of in a negative light, when someone else expects us to show up, we do.

No matter how passionate you are, there will always be areas of the business you simply don't feel like tackling. For some biz owners, it's having difficult conversations with staff, while for others it's looking at the financial numbers or website analytics. These are things we know we have to do, but we put them off until they become an issue.

Likewise, when it comes to business goals, we can have all this fun making plans and creating masterpieces with Post-it notes and sharpies. Yet months on, those goals remain simply that – goals – rather than things we have actually accomplished for the business.

Having people around you who not only understand these challenges, but who can also keep you accountable, can mean the difference between a business that merely survives and a business that thrives. How are you currently being held accountable for the things you've promised yourself you'll do?

Are you showing up for yourself in the areas you know will help grow your business?

Are you staying on top of the more tedious parts of your business so they don't become a future problem?

Do you regularly check in with others about the business tasks and goals you said you would complete?

Do you have a way to get feedback from trusted advisors on your next collection, campaign or communication tactic?

Do you have a group of business friends you can call on to discuss everything from your pricing strategy through to how to deal with the dreaded comparisonitis?

If the answer to any of these questions is no, then you need to cultivate a supportive crew.

Throughout this book you have been taking action and setting yourself goals in order to sidestep the #hustle and build a business you love.

> *Whether it's because we don't want to let someone else down or because we don't want to be thought of in a negative light, when someone else expects us to show up, we do.*

And trust me, the business owners who manage to set – and get –their goals are also the ones who have people they can stay accountable to, and a biz support crew they can call on.

Who's in your crew?

Now, before you race off in search of the next online group to join, take a minute and consider who is already in your life. There's nothing wrong with masterminds or memberships (I run one of the latter), but we often have entire networks around us that we never think to use.

When it comes to cultivating a supportive biz crew, there are generally five groups you should look to create:

1. Your Core Crew

2. Your Bounce-off Crew

3. Your Creator Crew

4. Your External Crew

5. Your Aligned Groups Crew

What do these actually mean? Let's find out.

Your Core Crew

This crew consists of the people you can call at any time of day, who will be there to wipe your eyes when things turn to shit, or who will be the first to pop the champagne when it's time to celebrate. These are your ride or die people who you fear absolutely no judgement from, who want only the best for you and who you can trust to give you 100 per cent honest feedback on just about anything. While this crew will include your significant other, possibly a sibling or even your parents, it shouldn't consist solely of family members and/or your spouse.

Your Bounce-Off Crew

This is similar to the Core Crew, but you wouldn't usually run to them when you're having a complete meltdown (and hey, #NoShame, we *all* have those). This group is more likely to be made up of people who work in a similar or complementary industry to your own, i.e. people you can literally bounce ideas off. They are people you can rely on to chat through things like staffing issues, marketing ideas, pricing strategies, platforms and tools, and even things like recommending an accountant or lawyer. They are your #CollaborationOverCompetition biz friends, the kind you might even partner up with for a project, event or product collection. Depending on what the members of your Core Crew do, you may well have some of them in this group as well.

Your Creator Crew

This next group is all about helping you with the more creative elements of your business, especially your branding and marketing. These are the people who could help you with copywriting, photography, videography, visual branding, the 'tech' stuff (e.g. website design, analytics, linking your ecommerce platform with your email platform), event management, public relations, social media and even personal branding. One of the biggest challenges I hear from small business owners who are either launching or looking to scale is to find skilled creatives who 'get' them. Documenting this group allows you to see who you already know that you could hire or discuss ideas with first.

Your External Crew

I *love* my accountant. I know I sound like a complete nerd, but I'm loud and proud when it comes to promoting her business to clients, students and in my speaking gigs. The reason? Without her, I would have come up against some pretty massive obstacles that could have cost me big time. My accountant is part of my External Crew. This group is made up of people like your accountant, bookkeeper, lawyer, nanny, cleaner, dog walker – basically anyone who makes the day-to-day running of your business (but doesn't work in the business) easier.

Your Aligned Groups Crew

While this group is last in order, it's by no means last in importance. This crew consists of all the people you know from the various groups you're a part of. These may be your church friends, people from your sporting club, friends from an online group, people inside a business community on Facebook, a book club or even your school alumni.

How can these people help? In so many ways.

Apart from practical advice related to various areas of business (e.g. a membership group actually showing you how to launch and grow a membership for your own business), they may help you with opportunities to meet your ideal audience and share your journey.

For example, let's say you're a health coach who works with girls aged twelve to fifteen on body image and confidence. You may also play basketball once a week. You might then look at where you're playing basketball (e.g. the sporting complex or club) and see if there's an opportunity for you to run an event where you would have the opportunity to chat with parents of girls you work with, or with the girls themselves, about topics you're an expert in.

Alternatively, you may have just launched your resort wear fashion brand and also be part of a school alumni. You may offer some of your items for a charity raffle related to the school in return for a spot in their newsletter or social media, and/or go and talk to senior school students about your career in fashion and your new brand.

> Caveat: people are your best asset. They should always be treated with respect. Don't expect your cousin's wife to offer free legal advice when that's her profession, and don't hound your local community group to get you sales. Both of these things are just #PlainWrong.

For most of us, there will be people who cross over different groups, and that's completely okay.

The point is to remember who we have in our networks and how they may be able to help us reach our business goals.

Your Internal Crew

One group you may realise is missing from the above is your Internal Crew. This may include your internal staff, suppliers, contractors and manufacturers. People whom the business just wouldn't work without.

This group should be considered on its own. It will shift and change, much like the other groups, but this group will also be reliant on you, as the business owner, for guidance and help, rather than the other way around.

Who is in your current Internal Crew?

Who would you like to see in this crew in the near future? (For example, you may want to hire more staff, or even your first staff member.)

Cultivating a successful Internal Crew

Write a list of all of the people in your Internal Crew, then consider the skills and expertise they can offer. Remember to note down every skill they have, not just what their job is 'on paper'. For example, perhaps your virtual assistant worked as a bookkeeper prior to starting their virtual assistant agency. They may have skills that can help you in other areas that you may not have considered.

Similarly, your suppliers or manufacturers may have experience in your industry outside of what you have directly hired them for. For example, perhaps they are helping another client with more sustainable manufacturing processes and you are interested in that as well. They may also have networks that you can leverage to help you with other parts of your manufacturing, such as swing tags, packaging, customs, or fulfilment centres.

Look at the list you have written down. Is there anyone missing? Are you accounting for all the skills and experiences these people bring into your business?

Future-proofing your Internal Crew

If you have read this book in sequence, by now you will have some idea of your ideal audience, how you'll make money in your business, where you want the business to be tomorrow and the avenues (such as marketing) that you'll use to get there.

I can't emphasise this enough: people really are your best asset.

Look at the list you have written down for your Internal Crew. How often are you connecting with these people? Do you offer a considered welcome gift when people join the company (even remotely)? A handwritten note from the company founder (i.e. you) can do so much to help people feel welcomed, seen and valued. Likewise, a welcome lunch (even over Zoom/Skype for remote staff) can help people feel energised and excited about their role.

On that note, do you have regular connection sessions with staff where you don't talk just about work? This could be a monthly potluck lunch, a quarterly night out, a Friday film afternoon or simply a weekly fifteen-minute catch-up over coffee in your office kitchen.

Work is such a huge part of who we are today and you want to ensure that the people who work for you feel that you acknowledge them as people, with lives and families outside of work. A simple (and genuine) 'How was your weekend?' can do wonders for staff morale.

How are you showing up for the people who show up for you?

One last point to consider when it comes to your Internal Crew is who else you may need in the mix in the future.

It can be hard to know what you don't know, i.e. who you will need in your business twelve to twenty-four months from now. But it is worth spending time reviewing the work you have done up to this point, and then looking at your Internal Crew with these things in mind.

For example, perhaps you wanted to add online courses into your revenue streams, but won't have the time to build these yourself, so you need someone who can work part-time in your business and build these alongside relevant email sequences, webinars and Facebook ads.

Or you may have decided that you would really like to move your product-based business from 100 per cent online to include a physical store as well. If that's in your plans, then you could review your Internal Crew for someone who may want to become the manager for this physical store.

When completing this exercise, you may come up against a whole load of blocks, either around not having the money to hire these people or the hires being so far in the future that they're not worth worrying about. But no matter where you are in your business, taking the time to consider who else you'll need is never wasted. At a minimum, it forces you to focus on what the business will look like in months and years to come. It also allows you to start thinking about who you

already know who could fill these future staff gaps, and how you can help them upskill and gain experience that will benefit both them and you in the future.

 Need help with this? The free Skills Matrix tool available at mydailybusinesscoach.com/purpose will help.

People really are your best asset.

The Non-work Network

Lastly, there's an important group any small biz owner needs to cultivate and that is your Non-work Network.

Having people to talk to and socialise with who have *nothing* to do with your business is imperative to your mental health. Talking 100 per cent about work can leave you feeling overwhelmed and out of sorts. While I don't believe in a perfect work–life balance, I do believe there are things you can do to ensure work doesn't completely rule your life.

Write down the top three people in your life who are not related, in any way, to your business.

How often are you showing up for them?

How often are you initiating contact and making the effort to see them or phone them?

What would it feel like to schedule regular catch-ups with these people?

For many of us, that last question may lead to a sense of relief and peace, knowing we have a regular time to completely switch off, laugh, love and listen to the people who matter most to us.

As much as you love your business, it's important to have a break from it from time to time. Cultivating your Non-work Network may help you do this.

Maximise the mix

One of my favourite things about living in London was the sheer diversity of people. Melbourne (where I now live) is incredibly multicultural, but there's nothing like getting on the tube in London and hearing eight different accents and languages in one train carriage. I remember looking around the table at a birthday celebration in a London pub and there were friends from Bahrain, India, Vietnam, South Africa, Australia, England, New Zealand, Sweden, the US, Indonesia and Germany.

When it comes to creating a biz you love, diversity is key. Ensure that the groups you're cultivating are not just cookie-cutter clones of yourself – your upbringing, your culture, your religion, your ethnicity, your sexual preferences, your education or experience.

Too often, we as small biz owners can exist in bubbles where everyone looks, acts, sounds and feels like we do. The best thing you can do for your business (and life in general) is to ensure that you're surrounded by a diverse group of people who can provide insights and ideas you may never have considered.

Action

Take a few minutes to reflect on the people who will help you build your business.

 Then answer the following questions in as much detail as you can.

1. How are you currently staying accountable to the goals and tasks you have set yourself? Are there particular people (staff, friends, family) who help you do this?

 2. Review the five business support crews, then use the template on the opposite page to list these people.

3. Create a plan for your Internal Crew. Who is missing from this group? How are you truly connecting with these people?

4. Consider where you want your business to be in one to three years (you may wish to read back through chapters 6 and 7). Do you have people in your Internal Crew now who can help you get there?

5. Consider who is in your Non-work Network. How are you showing up for them? How can you ensure you are regularly catching up with them (whether online or in person)?

6. Are you cultivating diverse groups of people in your crews? If not, how might you change this?

CORE

1.
2.
3.
4.
5.

EXTERNAL

1.
2.
3.
4.
5.

SUBJECT

Me

ALIGNED GROUPS

1.
2.
3.
4.
5.

CREATOR

1.
2.
3.
4.
5.

BOUNCE-OFF

1.
2.
3.
4.
5.

Amy Anderson O'Day, *founder, Comfort Station*

Amy Anderson O'Day is the founder behind Comfort Station, a London-based jewellery and accessories brand that has become the go-to for people seeking meaning and craftsmanship in their investments. Operating for close to two decades, Comfort Station offers handmade, considered, and often customised pieces ranging from engagement rings through to pendant necklaces.

You didn't originally set out to be in this business, right?

That's exactly right. I had left the Ruskin in Oxford with my Art degree, and had moved back home to London. I immediately set up a stall in Portobello Market to fund my art practice, to allow me to afford to get a studio and move out from home. I made a whole bunch of different things; I had some clothes made and was selling those, plus bags and accessories that I'd made myself. It quickly took off and I was soon selling to shops via the market, then at London Fashion week. I found I was being so creative that I didn't really miss the fine art practice that I had and I just learned all the processes I required on a need-to-know basis. So, not exactly self-taught, but an organic progression of learning based on what products I wanted to make.

What was your upbringing like and did it influence your decision to start Comfort Station?

My parents were both entrepreneurs, though I've never really thought of them like that! I was brought up in a very creative background. My parents ran their own business initially as art dealers and then my mum, while I was very young, ran her own contemporary art gallery and then moved into art consultancy. It just seemed very natural to me that you didn't have to work for somebody else, and my parents had a very balanced working and home relationship, so I had no issues as a woman about starting something up on my own. They were incredibly supportive of everything I did, and I think – just quietly – very good role models; it's probably not a coincidence that my brother runs his own business as well.

What is the 'why' behind your business?

When I started Comfort Station it was just an outlet for my creativity – what I wanted to make at the time. But over the years that has changed, as I have had the opportunity to decide which path to take it down in response to the things I care about and what resonates with me. The business has evolved to these beliefs, and now I feel it's a very good reflection of how I feel about the world. We create small-scale, high-quality, lovingly produced items that are unique and are imbued with meaning – items to last and be treasured, no matter what year it is, and by future generations. Slow fashion, sustainable, made with as little impact as possible, made locally and by skilled people with real thought and attention.

You started selling at markets. What lessons did it teach you? How long did you do it before you were able to make a full-time living?

Photo © Mathew Wilson

I enjoyed it immensely and the lessons were huge. From understanding how to interact with your customers, understanding the psychology of shopping, the importance of merchandising and how to do it, representing your brand, balancing the books, how much to invest each week – the list is endless. I learned entirely from scratch how to run a business in the market. I was very, very lucky as well. I hit Portobello Market right at the time when it was booming. It was so creative, so packed full of designers and creativity and, most importantly, a very supportive and enthusiastic customer base. This was before cheap imported goods flooded the market. The time I was there, in the early 2000s, it was a really good way to make money, and people were actively pursuing original design. It was gruelling as well, the 5 am starts I could only manage since I was in my twenties (I'm a night owl naturally),

and dealing with the outdoor elements isn't easy, but I found it incredibly fulfilling and I feel lucky to have started there in such favourable conditions that allowed my business to flourish so quickly. Because I was living at home with my parents straight after college, that also gave me a buffer to be able to experiment more, but I had moved out of home and was doing the business full-time well within a year of starting, with some savings to boot.

Until recently, you had a beautiful boutique just off Brick Lane in London, which became a destination space. You created a really unique aesthetic. Did you intentionally set out to make a 'different'-looking boutique or did it just happen organically?

It happened pretty organically. I knew I absolutely did not want those traditional glass boxes that every jewellery display shop seems to have and I thought, surely there must be a better way to display products? So many jewellery shops have no atmosphere when you walked in. It's like the products have to do all the work, but it makes the shopping experience so dull. I also had a few thoughts governing the layout – things always look bigger when you can see the floor, so I raised most of the elements so they were suspended; it creates a feeling of light and space. I had had a fair bit of experience doing London Fashion Week and Paris Fashion Week and realising it was important to capture people's attention in order to get them to come into your stall too, so I applied those ideas to the shop. The shop was created on a bit of a budget but that wasn't actually by design. I had a lot of luck with finding key elements cheaply, and I wanted a mix of old and modern so it just came together very quickly, luckily.

Comfort Station is known for its handmade craftsmanship and its quality materials. Maintaining such a business for close to twenty years is a massive feat, particularly in this era of 'Instagram brands' and people being able to shop for cheaper alternatives or contact offshore factories from their

phone. Why do you think your business has flourished?

People are coming to us to get something entirely unique that has been made with real craftsmanship by people that care about how it is made. They are buying something that will be a future heirloom, something to last, from the people that make it. There is accountability. There is an understanding of the product and how it came to fruition. There is a conversation and there are shared principles; there is a joint understanding of the meaning of the piece and the time that has gone into it.

What we do is extremely niche and it is recognisably made by us. And people buy from us not just because of the quality of the product but because of the thought behind it. My jewellery collections are conceptually led and people find that interesting and exciting – they love the stories behind the pieces, whether it's a secret obscure engraving, or something that references something else. They make you think. They aren't just pretty things to adorn about your neck, they have their own stories to tell and their own power. And the people that buy from us are the kind of people who resonate with that and respect all the processes and wouldn't want a cheap knock-off. Which is why I'm never too concerned when I hear about a mass-market copy of our work (of which there have been several in the past), because they are not the same thing. They aren't even close. And as such, they have never affected us.

You recently decided to take a sabbatical, move to France and close your London boutique. What would you advise someone else who's been in a business for a while and is considering doing something similar?

I think it's really important to love what you do and to not feel stale, and after fifteen years in Cheshire Street [East London] it was beginning to feel stale for me. Not the brand, not the jewellery, but the place and how my life fitted into it. The human brain needs challenges, it needs to make

new neural connections, and I was feeling very unstimulated in the same location. The rent was going through the roof for what is basically a tucked-away quiet street, and fifteen years seemed like a good cycle, so instead of just going straight to a new shop somewhere else, I decided to throw everything up in the air.

The only other time that my hand was forced to do something that seemed scary for my business worked out to be the best thing I could ever have done. Nine years ago I fell pregnant with my twin boys and I realised with twins it just wasn't realistic to keep doing the shows, which were innately stressful and required a lot of energy and travel. I had been doing Paris Fashion Week for seventeen seasons, it felt like a part of me, a part of my identity, a huge backbone of the business. I was scared to throw it away even for one season. But I did. I stopped, thinking that I would come back to it, but it was the best thing I ever did. My business flourished. I made more money with less stress working solely on direct sales and the few wholesale accounts that really wanted my business and so were easy to work with. I worked less days, had a better work–life balance and was more profitable!

So moving to France and giving up the shop, I somehow knew would be one of those major things because it seemed so big at the time, but I also knew deep down that I needed to just shake everything up again and see how it would land. Often the best decisions are the scariest, but I am 100 per cent happy that I made the right decision in each of the big decisions I've had, and very proud that I was active in my life choice this time round rather than it happening by default.

My advice would be to really question the things that you think you need, since had I given up the shows a lot earlier I'd have saved myself a lot of stress.

What's been the best advice you have ever received when it comes to business?

Never forget your USP. That may sound really obvious, but it becomes very easy to focus on other people's successes when things aren't going well and be confused as to why it isn't necessarily happening for you yet. I went to a great lecture early on by the British Fashion Council that really made me focus in on that. Never lose sight of that; all decisions come naturally as a result.

What do you want Comfort Station's legacy to be?

I'm not sure I've ever thought about that. I would say hundreds of happy customers with fond memories of buying and wearing their treasured pieces. Pieces which make them feel strong and empowered. Pieces which make them *feel* and remember. Pieces which get passed down and the meaning becomes explained to the next generation. I think I'd be very happy with that.

comfortstation.co.uk

⊙ @comfortstation

Photo courtesy of Comfort Station

How will you grow?

PAGES 193–207

In 1991 I was eleven years old and just getting to a stage where I looked at boys with a strange fascination.

That year was also the year my eldest brother finished high school. As he attended an all-boys high school, his yearbook was a source of great intrigue for me. I would always find some way to steal it and pore over it with my best friend Julia, laughing and giggling in the way only tween girls can.

I remember looking at my brother's photo in the 'Class of '91' section. Underneath each student's photo they had printed their answer to the question: what do you want to be in the future?

My brother's answer? 'To be content.'

While writing this book, I texted him to ask if he was, indeed, content. He replied:

Content enough, but if you are ambitious you can't be completely content. Maybe with the wisdom of a few years, I would now say 'To be content in my striving, to be looking over the horizon, to be growing, to be loving and present for those I love and to be making a world that is a bit better for my having been here.' I guess as you get older, it gets more complicated.

His response made me think.

Can you be ambitious and still be content?

Can you be happy with where your business is now, but still want to grow and evolve?

I believe business can be built without needing to #hustle 24/7. I also believe that you can appreciate where you are now in your business while still wanting it to grow.

In this chapter, we are going to look at the ways you can fuel growth in your business without fuelling overwhelm and stress. Increasing your brand awareness and stepping up your sales doesn't always mean you need to #HustleHard or sacrifice time with your loved ones. By being strategic and smart, it is possible to sidestep the #hustle and build a business you love.

What does growth mean to you?

The first thing to clarify is what growth actually means to you.

For some of my clients, growth is all about profit, while for others it may be about their personal growth or having a greater impact in the world. Growth to one small biz owner may be about having offices in multiple locations, while to another it could be about working only four months of each year.

What does growth mean to you?

What will your business look like in the future? Is it a global empire or have you kept it intentionally small?

In chapter 7, we looked at where you want your business to be in twelve months, two years and three years. Consider now, where do you want the business to be in five to ten years?

Which parts of the business have to grow in order for this to happen? How will you *feel* when this growth happens?

The second thing to consider is what impact you want your business to have in the long term.

In conversations I have with clients – and even with some of the business owners profiled in this book – I have asked the question: What do you want your business's legacy to be?

What do you *want your business's legacy to be?*

Do you want to have employed women who otherwise may not have been able to bring in an income?

Do you want to teach people a skill so that they become self-sufficient?

Do you want to create real change in your industry by doing things in a new way?

Do you want to help future generations by creating a sustainable, environmentally-conscious business?

Do you want to show others what's possible?

Do you want to alleviate overwhelm and stress by helping people create organisation, systems and processes?

What do you want your business to be known for?

As discussed in chapter 3, Warby Parker is a US eyewear company founded by four college kids, Jeff Raider, Andrew Hunt, Neil Blumenthal and Dave Gilboa. They decided to take on the eyewear manufacturing giants and create glasses that were affordable and also gave something back to those less fortunate. Initially they started with a one-for-one model (which still exists) – for every pair of glasses sold, they donate a pair to someone in need. To date, they have donated more than five million pairs of glasses.

As their business has grown they have been able to increase its impact, providing training to enable people in impoverished areas to give eye exams, offering vision care and eye exams to children in school, and helping people in more than fifty countries worldwide. When they founded their business back in 2010, I'm sure they didn't know just how successful it would become, but their desire to give back was a driving force of the business.

What is it that you want your business to be known for?

Take some time to consider the questions on the opposite page (you may wish to revisit the work you did on your brand in chapter 4).

How does your answer influence your perception of 'growth'?

Loyalty, love and the Buyer Cycle

Now that you have an understanding of what growth means for you, it's time to consider how to work towards that, with practical tools and tactics.

No business is an island. In chapter 9, we looked at who else you need to support you in building a business you love.

Now it's time to consider how *you* and your business will be that support for your customers and clients. How will your business meet their needs in the years to come?

How can you create a business people are loyal to, both now and well into the future?

What sorts of problems might they be facing that your business could solve?

Remember my favourite tool, the Buyer Cycle? The reason I prefer using a circle (or cycle) is because there is no clear end. People who purchase from you and become advocates help the cycle continue, either by promoting your business through word-of-mouth marketing or by investing in the business with a purchase (or, ideally, both!).

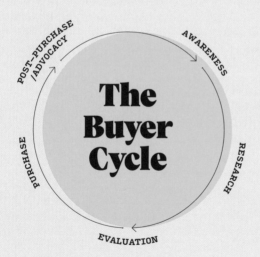

Consider what growth means to you.

Then consider how you might tweak your business model and offerings to meet the needs of your audience.

Will you move your manufacturing to another location to help boost employment in that region?

Will you change your materials to reduce your impact on the environment?

Will you move your offline products online so that the benefit can be felt globally, rather than within your region alone?

Will you change your business model so that you specialise in one area and go deep (think Grand Canyon), thereby increasing the impact you can have on those who need it most?

How can you tweak your business in the future to help fuel customer-led growth?

Brands like Toms, Warby Parker and Thank You fuel future growth by giving back in some way and telling that story across all touch points. If they were ever to pivot their product offerings (and Thank You has in the past – for example, discontinuing their food range in 2017), their audience still comes along, as the loyalty remains to the brand rather than to the product they offer.

How will your changes help build loyalty between your brand and its audience?

Taking a tiered approach

Growth can be a hard thing for small biz owners. Not just when they're actually experiencing it, but also when considering *how* they might grow. We often equate growth with more stress, more overheads, more cost and more headaches.

It doesn't have to be that way.

One way to look at how you might grow your business in the future is to consider a tiered approach.

For example, let's say you sell handbags. You have collections that range from $50 to $300. You have a solid audience who love your designs and also love that you produce ethically and sustainably, which aligns with their personal values (remember The Ladder concept from chapter 3).

Looking at this business through a tiered lens, you might consider producing smaller products out of leftover materials, as an entry point (such as a $30 keyring or business card holder) right up to a limited-edition range of bags, which you either create yourself or partner with an artist to produce. These may come out just once a year, and you can tip the pricing scale at $700 per item.

A tiered approach means you not only have the opportunity to bring in greater total revenue, but you also open up the brand to a wider audience.

Likewise, if you are a health coach, you may decide to tier your top revenue stream, which is an online course. For example, the online course 12 Weeks to a Healthier You sells for $1997. With a tiered approach, you could offer a self-paced video course (using the same material) for $897, the current course at $1997 and a VIP experience that includes the course plus one-on-one time with you and entry to a five-day health retreat with you for $9997.

Again, you have opened up the earning potential and provided different experiences for your audience. You are allowing them to choose what best suits their needs.

How could a tiered approach work to fuel growth in your business in the future?

It may help to go back over your work on audience from chapters 3 and 6. Could one of your ideal audiences start on one tier of your business, then graduate to the next after a few months or years?

We often equate growth with more stress, more overheads, more cost and more headaches. It doesn't have to be that way.

A lifetime of customers

For a business to succeed, it needs to have customers. For some businesses, their customers will be largely made up of the same people – people who choose to work with or buy from that business time and time again.

For other businesses, their customer base will be largely made up of new, first-time transactions.

Which will your business be?

Is what you sell a one-off product/service, or is it something people will need repeatedly?

Will your tiered approach and multiple revenue streams allow people to graduate from one product or service to the next?

Who is your ideal customer and what is their lifetime relationship to your business?

If you decide that your customer base is more often new buyers, you will need to have growth strategies in place that allow you to go wide – that is, capture more and more people in your Buyer Cycle through increasing brand awareness, partnerships and growing your email or Facebook Messenger list.

If your customer base is more often repeat buyers, you will need to have growth strategies in place that allow you to go deep. What can you offer that will enable them to grow even more with you? For example, this may mean introducing an annual membership where people can still get guidance and information from you once they have completed a three-month one-on-one coaching program; or, for a clothing business, it might mean introducing subscription boxes so customers can not only buy from you once, but know that each month they will receive an item to help them update their wardrobe.

How will you do this?

Action

Take a few minutes to reflect on what growth really means for your small business.

 Then answer the following questions in as much detail as you can.

1. When you think about your business in the future, what does it look like? Is it intentionally small? Is it an empire with global offices?

2. What is the impact you want your business to have and why is this important to you?

3. How are you building brand loyalty between your business and its key audiences?

4. What does the ideal customer lifetime relationship look like for your business? Will you need to go wide or deep?

5. What needs to change in your business – and when – for real growth to happen?

6. Is there anything that scares you about growth? Where do these ideas come from and how have they served you?

Dhiren Das, *founder, Relative Projects*

Dhiren Das is the founder of Relative Projects, a unique strategic design consultancy focused on how people experience urban spaces. He helps large organisations, developers and government institutions create city-shaping projects, with a human-first approach. Relative Projects' work centres on the idea that physical places need to be considered holistically – beyond buildings – to inspire people in their everyday lives. For this reason, Dhiren leads a team of cross-disciplinary urbanists to combine numerous perspectives to create the vision for each project.

What is Relative Projects?

Relative Projects is a strategic design consultancy focused on shaping the future urban experience. We are not architects, but rather apply a broad range of creative capabilities to find ways to make urban-renewal, city-building and precinct-scale projects more human and more inspiring for people in their everyday. This is not possible without tackling some of the big questions and joining the dots between the often separate worlds of economics and design, or commerce and contemporary culture. Our specialisation is in bringing these disciplines together. Currently our project team is made up of people with backgrounds in strategy, economics, design, architecture, retail, brand, policy, urbanism, culture and media.

By bringing these qualities together we have a very different and diverse perspective. Essentially our role is to come up with the vision that will help bring a place to life, and then be rationalised into reality without losing the integrity.

The studio evolved over many years, really. Although technically we've been operating for seven years, the idea behind the business really evolved over the last fifteen years. Back in 2004, I was working in London on a large urban infrastructure project for the city. What I realised then was that each consultant had a specific role which they would chip away at, only interacting with other consultants on the project every now and then. A big part of my job at the time was to communicate all of the consultant work to stakeholders, from the local community to businesses and the House of Lords. There were lots of specialists in each field, but very few people who could speak to all of those specialists in a meaningful way and understand their constraints, and what drives them. So what I did was set out to further my knowledge about each consultant's stream and, for that reason, each set of their problems. Eventually I could speak to architects, landscape architects and engineers, while also engaging with economists, brand strategists and communications teams as well. Back then, the word 'placemaking' was unheard of, and now it's possibly overused.

Since then, I've worked at every scale of design, from furniture and spatial to architectural and urban. At one point I partnered with an architect and we worked on hospitality, workplace, retail and public spaces. I learned a lot but the projects

Photo © Penny Lane

were not impacting the other layers, such as the organisational and cultural. I started to recognise the potential to look at design in a new way that is informed by more people. Now that viewpoint culminates in how Relative Projects creates places that go beyond just the built form, to address what makes for an inspiring experience that is culturally relevant and commercially viable – now and in the long term. All of these ingredients are essential.

What is the 'why' behind the business?

Relative Projects exists because the problems we face as individuals, as organisations and as a society are interwoven and deeply related. The urban realm is also one situation where we can address big ideas that impact at scale. We look for answers not only through technology, but also through the cultural and behavioural change that we promote and create. My belief is that by bringing people from a variety of fields along the journey together, we can look at new ways of designing, building, working in and experiencing cities that have a positive impact for the future. This is sometimes incremental and sometimes a single leap. It takes many stepping stones for our largest industries to transform, but the speed of change is increasing.

What was your upbringing like? Did it influence your decision to create Relative Projects?

When I was a kid, both my parents worked in conflict resolution and for NGOs based in Australia, Switzerland and several other countries. They worked on both grassroots programs as volunteers and with government institutions. My father also worked for tech start-ups who were developing very early online collaborative platforms in the nineties. Because of this, I was exposed to a huge variety of people from many nationalities, backgrounds and walks of life. Overall it gave me some perspective on the world at a young age. I think, more than anything, my upbringing exposed me to diversity.

Those experiences heavily influenced my decision to create Relative Projects. Diversity, deep thinking and a broad perspective is central to what we do, and it is essential to the work we create. Although a lot of our projects are with large organisations, such as developers, government, universities or institutions, ultimately we see our projects as potential vehicles to create change, in large and small ways. This change can only be achieved by bringing together all the disparate parts into one conversation. In a way, this is also something I learned from my upbringing.

You have worked with some huge brands, but Relative Projects isn't an in-your-face brand with crazy socials, your face plastered everywhere etc. Has this been an intentional strategy, to remain more subtle and sought out?

This is intentional. I feel it's important to ask the question – why do we need so much emphasis on creating and consuming a constant stream of media? How is it relevant beyond self-promotion? At what point does it dilute our message, or worse, our experience of everyday life? Personally, I have always believed that you can remain subtle, but still seen – and achieve what you set out to do in a more targeted way. I'm not against mass media, but am more focused on creating good work rather than talking about it. We are starting to do more communications each year, but this will always be considered and restrained.

What has been the hardest obstacle you have had to overcome as a small business owner, and how have you done so?

One of the hardest obstacles for me has been creating a new business model and service offering that is quite unconventional. I actually tested it ten years ago but the market didn't seem ready. No-one had really ever heard of a company that does the mix of what we do. For that reason, it often takes a while for people to understand how to engage with our services, but once they see the value of connecting the dots that we do, they are with us for the long term.

A lot of the work Relative Projects does is still very new to the masses, in terms of its concept (shaping places and experiences for the future). How does your pitch process work? Do you mainly get inbound inquiries or do you seek out places you think could benefit from Relative Projects' expertise?

We are providing our services to very specific decision-makers, who are often developers, global brands, large organisations, government and community. In many instances we'll receive a Request for Proposal from a client or collaborator, based on a large future project. We might collaborate with a large team including architects, landscape, economists, art curators, brand designers and others.

The client will be asking several teams to tender on projects, and it might be anything from the redevelopment of a waterfront, a new university campus or a mixed-use precinct. We do a huge amount of research and benchmark a vision for the project, or a strategy. This is where the practice of 'strategic design' comes into play, whereby several parallel forces are looked at under the one lens in order to analyse and resolve ideas holistically. There is a deep focus in our work around how we actually make a vision real, and that's where the complexity really lies. Anyone can have a big idea, but without the ability to interact with all the specialists, that idea may be lost in translation when it's getting built.

A lot of our work comes through our network of previous clients and collaborators who understand what we do, its inherent value and point of difference compared to others in similar fields to us.

How and where do you seek out help with your business?

We are constantly seeking to broaden our perspective through the eyes of others. So I guess in a way we seek help on a daily basis, from our team, our collaborators and clients.

I picked up Bruce Mau's book *Massive Change* in 2004. It influenced me a great deal back then, and I still refer to it. His thinking resonated with me, as it felt like there were not many voices at the time speaking about the need to radically redefine how we design the systems, structures, culture and behaviours that influence our cities. As he put it, 'It's not about the world of design, it's about the design of the world'.

Do you have any mantras or quotes that you come back to, again and again?

Years ago I used to have a Post-it note on my computer that read: 'Make It Happen'.

What do you want Relative Projects' legacy to be?

So far we've been able to work with organisations to help them think differently about the value of design and also the value of investing in their community. In the long term, I want Relative Projects to make a difference for people beyond the financial imperative, where our ideas and actions contribute to a more equitable culture through new ways of designing, doing business, and living and connecting with each other.

relativeprojects.com

◯ @relativeprojects

How will you make it happen?

PAGES 209–221

Sometime in late October 2018, I decided that I would write this book.

While half-watching *Mindhunters*, my husband and I began chatting about 2019.

'What do you most want to have accomplished by the end of next year?' I asked him. We both knew the answer. It was to have achieved our goal of having a much longed-for, healthy, second child (I was two weeks pregnant at the time). He smiled at me.

'Aside from that, obviously?' I asked.

He paused, then, without answering, asked me the same question.

'I really want to have written a business book, or be well on the way to having written one.'

'Then make it happen,' he said.

'It's not that easy,' I instantly replied.

'What would My Daily Business Coach say?' he said jokingly, then added in a more serious tone, 'If it means that much to you … well, what would you need to do to make it happen?'

'God, I don't even know where to start,' I sighed.

'Well, you're the one always saying anything is possible. You just need to figure it out and make it happen.'

I picked up my iPhone and typed out a new top twelve tasks list with the heading 'Write Business Book'.

The very next day I researched publishing houses, looking at the types of books on their list and their book proposal submission guidelines.

A few days later, I spent some time considering my own networks and shot off an email to the person who had been in charge of a postgraduate diploma in editing and publishing that I had undertaken a decade earlier. I asked if he could recommend any publishing houses I could approach about 'a business book that I have in mind'.

He sent me on to someone else, who in turn suggested I talk with someone else. After a few months I landed a meeting with the wonderful people who have published the book you're now holding in your hands.

Getting to the stage of being offered a book deal took time, and writing this book wasn't always easy. I was juggling a four-week-old baby when I began mapping out the content, and a five-month-old (in addition to my older son) when I finished writing the first draft. I had four dedicated hours of child-free time per week to write (thanks to two incredible women who would mind my youngest son). I topped this up with the occasional Sunday afternoon and the odd 8–11 pm writing session midweek.

If I came up with ideas for the chapter stories, questions to ask a creative biz owner, or a new activity, I would either send myself a voice message or quickly add a note in my iPhone. I initially mapped the entire book out using Post-it notes, then later used grids on a large whiteboard to mark sections off. I broke down this seemingly mammoth task into small steps that I could consistently take action on.

I switched my phone off during those weekly writing sessions, and I often turned off the internet in my office as well, to keep distractions to a minimum. I had sub-goals for word counts and chapter completions. In short, I knew what I wanted to achieve and I took the necessary steps to make it happen.

No one was forcing me to enter the office at 8 pm and write. No-one was forcing me to switch off the TV or get off social media and do the work. I didn't have weekly check-ins with my publisher or editor. I wasn't accountable to anyone in the time between signing my contract and submitting the manuscript. I just knew that writing a business book was something I truly wanted to do. I simply had to push myself. *If it is to be, it is up to me.*

When I was growing up, my mum would often tell my siblings and I that 'If you have time to talk on the phone, you have time to do the washing up'. If I had time to watch Netflix, edu-crastinate on YouTube, or scroll social media, I had time to work on my business goals – this book being a big one.

The late, great Muhammad Ali once said, 'The fight is won or lost far away from witnesses – behind the lines, in the gym and out there on the road, long before I dance under those lights.'

Like roots that grow far beneath a tree trunk, the actions that you take 'behind the scenes' will determine whether or not your business succeeds.

Sidestepping the #hustle does not mean sidestepping the work that all successful business owners will undertake to make things happen. For you to build a biz you love, YOU have to be prepared to build the business.

While writing this book (and working another day each week in my business, coaching, recording podcasts and creating online courses), I maintained my life outside of work. While the volume of work at times was high, the work itself wasn't so hard as to push it into #hustle territory.

Consider a marathon or half-marathon runner. They're not 'hustling' towards the finish line. They know where they're going, they have considered how they will get there, they have prepped, they've planned out what they need to stop, start and keep doing in the months (or years) leading up to their goal, they have cultivated a support crew and, most of all, they understand that the journey offers as many opportunities to learn and improve as the final destination.

In this chapter, we are going to look at the **Sidestep the Hustle Framework** that will help bring together everything you've learned in this book. Depending on where you are in your small business, this will involve doing some work. Remember when I mentioned that nothing changes if nothing changes? If you want to ensure that the education you have gained from this book actually impacts your business, then you will need to implement it.

Reading a book won't change your business. Taking action on what that book has taught you will.

I am yet to consult or coach a client that has it all together, all of the time. Those who have been able to build a successful business without 24/7 #hustle have one thing in common: they are clear on their direction and they take small, consistent steps to make it happen.

Let's look at how you can do the same.

The Sidestep the Hustle Framework

A framework is basically the structure upon which things are built. When looking to sidestep the #hustle and build a business you love, there are foundations that need to be laid and maintained.

Throughout this book we have discussed the need to:

1. Understand and embrace your 'whys' – the beliefs that led you to start your biz.

2. Embrace where you're at right now in your biz and accept that you may not be great at everything (yet!).

3. Understand who exactly you serve and how you will best serve them.

4. Relay your business's USP, values and impact through your brand.

5. Connect with your audience in a place and at a time that cultivates loyalty.

6. Map out your money and review your profitability.

7. Determine what you most want from your biz – both now and in the years to come.

8. Plan the path forward for achieving those goals.

9. Cultivate a support crew of people who want to see you succeed (and can help you).

10. Consider what growth means for your business and the legacy you want it to leave.

In each of those areas, you completed various activities to help bring overall clarity and direction to your business.

The Sidestep the Hustle Framework provides an at-a-glance view of where you are in the cycle of making things happen, and it allows you to identify areas for growth and celebrate the areas you're excelling in.

I believe that building a biz you love doesn't stop when you have ticked all of the boxes. A business is a living thing; your needs and those of your audience will change and evolve over time. Therefore the framework is a cycle you can revisit time and time again – whether in response to a new product or service offering, a brand expansion or revision, or a change in your personal life that impacts the way you run your business.

Where are you in this cycle?

What can you confidently tick off?

Where are you hesitant?

STAGE 8:
ALL ABOUT FUTURE

You have made it happen. You now know what it will take to accomplish your future biz goals and you are willing to become who you need to be to make it happen. You also know that nothing is concrete and so this cycle will begin again in parallel with the next evolution of your business

STAGE 1:
ALL ABOUT YOU

You know the beliefs, values and the 'why' for your biz. You know where you're at right now in your business (including gaps in key areas) and your own strengths and areas for improvement when it comes to making things happen.

STAGE 2:
ALL ABOUT THEM

You understand your audience deeply, know (and have validated) their values and what they most need from your biz. You know which problems you solve and how you can offer the most desired solution.

STAGE 7:
ALL ABOUT GROWTH

You understand what growth means for your business and the long-term impact you want it to have on the world. You know the ideal customer lifetime for what you offer and how to cultivate genuine brand loyalty.

Sidestep the Hustle

STAGE 3:
ALL ABOUT BRAND

You know what you are saying, how you will say it and where you will market the brand to connect with your audience, cultivate a community and attract conversion. You have a brand that aligns to your 'why', has a strong, clear vision and resonates with your ideal audience.

STAGE 6:
ALL ABOUT CREWS

You know that no business is an island. You have cultivated five key crews that will keep you accountable and offer varying levels of support. You understand the need for a strong Internal Crew and how to create – and retain – one.

STAGE 5:
ALL ABOUT GOAL GETTING

You know where you want the business to be now and in the next three years, what an awesome year looks like for you and which goals truly impact your biz. You have a plan to not only set, but also get, your goals. You have ways to frequently analyse your progress and pivot if necessary.

STAGE 4:
ALL ABOUT PROFIT

You know your own Survive and Thrive figures and what financial success really means to you. You understand which revenue streams are most profitable, how to market them and where your recurrent revenue opportunities lie.

Planning the gaps

If you're like most small biz owners, there will be gaps in the cycle. Stages you can't tick off just yet.

In chapter 8, we looked at mapping out Your Awesome Year, creating your top twelve tasks lists and taking the time to schedule in action.

Look at the stages in the cycle where you haven't been able to confidently tick off an item, then consider:

1. Why is this? Is it due to a lack of knowledge, resources, time or money? Or are you holding yourself back from committing to it?

2. How might you complete this stage (until the next iteration of your biz) with your current circumstance?

3. When will you action this? Set a deadline and stick to it!

4. What small steps could you action this week that would help move you forward in this area of the cycle?

The Weekly Business Review

One of the best tools I've come across in my career is the Weekly Business Review (WBR). I first encountered this during my time at Amazon in the UK, and it has become a key tool for my own business and for the businesses I coach and consult for.

A Weekly Business Review is exactly what it sounds like – a way to review, weekly, where you're at with your business and its goals. Using an Excel spreadsheet or Google Sheet, you first mark out the weeks of your year (calendar, financial etc.). Then in the first column you list all of the key activities for your business, starting (usually) with the revenue goals and projected profit, then adding items like key industry dates, marketing activities, production, account management, internal and media/PR. The activity areas you choose to focus on will differ from business to business.

The point of the WBR is to have a high-level, at-a-glance view of where your biz is week to week.

Could you create a WBR for your business?

If this is something you would like to explore, head to mydailybusinesscoach.com/purpose for more information.

Maintain to retain

Do you like to make New Year's resolutions? I do. #NoShame

Have you been able to accomplish every New Year's resolution you have set? Me neither.

And we're not alone. Research conducted by Stephen Shapiro (with help from the Opinion Corporation of Princeton, New Jersey) looking at New Year's resolutions found that only 8 per cent of people who make them will actually accomplish them.

Eight per cent.

As I suggested back in chapter 7, setting goals is one thing. Getting those goals is something else entirely.

Whether you're using a WBR, a monthly plan, an AGILE whiteboard or a ninety-day sprint cycle, your ability to maintain it will determine your ability to retain business growth.

As Seneca the Great said, 'Luck is what happens when preparation meets opportunity.' While it can be easy to dismiss successful biz owners as 'lucky', they have created a system that enables them to understand where they are, at any point, in relation to what they want to achieve. They then use this system to determine their next step, looking at what they need to increase (or decrease) in order to make things happen.

The key to being able to sidestep the #hustle and build a business you love is in not only planning what you need to do, but in actually doing it.

Consider the tracking method you have chosen above (e.g. AGILE, ninety-day sprints, monthly plans).

How will you ensure this is maintained? Will you gift this to a staff member to own? Will you maintain it yourself? Will you check in on this weekly or daily? How will you create a habit out of your maintenance?

Nothing changes if nothing changes. Having a WBR or AGILE whiteboard will mean nothing without a set frequency for maintaining and working through it.

Who do you need to become?

This book will have done one of two things: inspired you to take action and make things happen, or left you feeling overwhelmed and defeated. My intention is obviously the former (#shock), but if you're in the latter camp, consider how YOU are holding yourself back from building a biz you love.

It may sound harsh, but if things are really going to change in your business, it is you that has to lead that change.

We can all think of at least one situation in life when we were forced outside of our zone of familiarity and into foreign territory, with the experience changing us for the better.

Falling in love, living overseas, becoming a parent, taking on a promotion, moving out of home, buying a first home … starting a business. These are all stages in life when we are forced to shed the skin of who we were yesterday to make way for who we will be tomorrow.

In chapter 10, you looked at the legacy you want your business to have. Who will you need to be to lead that?

How might you be holding yourself back from what you really want, when it comes to your business?

How are you preventing growth from happening?

Who will you need to become to truly make things happen?

Action

Take a few minutes to reflect on how you will truly sidestep the #hustle and build a business you love.

 Then answer the following questions in as much detail as you can.

1. Work through the Sidestep the Hustle Framework. Where are you at the end of reading this book? Where are the gaps? Where can you celebrate your achievements?

2. How and when will you close the gaps in the cycle?

3. How will you maintain your plans to retain your biz growth and your audience's appreciation and loyalty towards your brand?

4. Who will you need to become to truly make things happen?

Nicolle Sullivan, *founder, CULTIVER*

Nicolle Sullivan is the founder of CULTIVER, a luxury linen homewares, apparel and accessories brand. Nicolle started the brand while on maternity leave, making a career change from the corporate world. In 2018 the online-only business launched its flagship physical store in Australia. Today CULTIVER enjoys international stockists and a loyal following who seek out its quality, understated designs.

How and when did CULTIVER start?

CULTIVER started from my home when I was on maternity leave with my first daughter, in 2011 (we launched in 2012). I had the time to research and test my ideas in a small way. I had already decided on a career change, so this was one of the things tried in deciding what that would be.

This business has meant a career change for you. What was the final catalyst that made you decide to take the leap?

Having my first child coincided with me deciding to change careers, so the decision was split rather than all at once. For me it was more a question of 'de-risking' the idea until I was comfortable to go forward with starting a business, rather than being brave enough to take a big leap. I wish I could say I had a vision from day one that it would be a huge success, but as I had already worked very hard to save in my earlier working life, plus had a young family, mortgage etc., I was scared to lose too much. So the mental process for me was: how can I test this idea in a small way? What is my plan if the idea doesn't take?

Given I was able to set up a website at low cost, my initial outlays were a minimum stock purchase (that I thought I could sell at the local markets if it didn't take online), some photography costs, a few hundred dollars on graphic design, and my labour (I didn't 'invest' in childcare until later, so initially this was all at night). Breaking it down gave me the confidence to take a step forward.

What did you know about ecommerce at the start of this journey and how did you learn what you needed to do to launch your online store?

I knew a lot about what I liked as a customer. I thoroughly embraced online shopping early on and so, as a buyer, I had certain site preferences. I guess a sign that I had more than a passing interest in the subject was that I thought a lot about what it was that made me prefer those sites – things like navigation, image style, tone of voice, curation etc. These things are a mix of brand and website experience and it takes both to make a great ecommerce experience, in my opinion. So a lot of what I knew came from my own shopping 'experiments'. The other part of my learning came from reading a lot online. I've always been a blog reader, and a few of the blogs I followed had started to offer online courses or just content about starting a blog, building a website, and all the other elements needed for those.

What were some obstacles you faced at the start and how did you overcome them?

The first obstacle was the lack of knowledge around setting up a website – this was quickly overcome through using the Shopify platform, which is very novice-friendly. Sourcing the product, knowing how to negotiate with suppliers, how to get the

Photo © Chris Warnes

As building a business often feels like non-stop problem solving and overcoming roadblocks, it helps to be skilled in working out what the problem really is.

products to Australia, how to get beautiful images for the website, how to get people to find the brand, how to make the website findable in search. And on and on and on. The way I overcame all of these was to ask for help, try things, iterate, learn from mistakes. So much of our progress as a company has come from expanding our network so that we have the right people around us at each stage of the business. To that extent, I try and think ahead – for example, we started working with a photographer early on who did a lot of work for the types of publications we wanted to be featured in, so we had a connection to those and this gave us a start PR-wise, as I didn't have the budget to pay for PR when we started.

What's the 'why' behind CULTIVER?

I wanted to offer a new way to shop. I could see that the best fashion ecommerce websites were moving to a curated presentation and boutique experience. Customers were getting addicted to the convenience of delivery and the choice of products from around the world. I wanted for myself a similar experience when shopping for my home, and I am even more sure now that younger, discerning consumers no longer want to shop in department stores or supa-centres for home goods, plus they are much more engaged with brands and a specialised offering.

You have been able to grow CULTIVER into a brand with international stockists and a loyal following. How did you approach stockists outside of Australia? Did you work through an agency or do it yourself?

We haven't used an agency or distributor – as our model was to be a direct to consumer brand, our pricing structure didn't allow for this. However, we found that there was inbound interest from stockists, and we also saw it would help us build brand awareness and reach a customer base that would never shop online, by partnering with on-brand retailers. We have gone with strategic partners rather than expansion at any cost,

so that we didn't take on more accounts than we could manage while we developed the brand and product range. It helps to have a clear idea of adjacent brands, so that you know which stockists make sense.

You now have a team you work with. Which role did you hire for first and how did you go about finding the right people to help you grow this business?

My first hire was an 'Ecommerce all-rounder', and it's a position we still hire for today. In a growing business, attitude and mindset is of utmost importance, and we've found if someone is excited about ecommerce, and being an all-rounder, they will go far. Typically within six months they are leaning into an area – marketing, production, customer service etc., so they run with that and we start hiring the next all-rounder.

What advice would you give to someone who, like you were, is currently in another career but longing to do something else more in line with their passion?

You often hear business owners say, 'If I'd known what was involved, I never would have started', which I agree with – it is blissful ignorance of how deep you'll be that enables you to move forward with starting at first. With that in mind, my advice would be: if you are passionate and ready to work really hard, just start and learn one thing at a time, move forward step by step. If you aren't sure what the 'hard work' will be like, perhaps take a six-month sabbatical and intern with an entrepreneur or business owner. Even as a PA, you will gain so much insight and education on what it takes for this, it will propel you on your own venture far beyond where you would otherwise be. Or you have the option of going back into your former type of work. Not everyone derives enjoyment from working in their field of passion. For example, I love food and cooking, but don't think I'd like being a chef …

Where do you seek advice? Do you have any business mentors, podcasts, or books you would recommend?

All of the above! As I've mentioned, I tap into my network and really value that, and I am a voracious consumer of content, be it articles, podcasts or books. It is the best antidote to the often-lonely position you find yourself in as a business founder – to search something super specific and have pages of Google results come up to show you that so many others have faced, and solved, the very same problem before you. I loved *Shoe Dog* for an insight into the long road to build a great brand, and How I Built This and Second Life podcasts.

What's been the best advice you have received so far in your business journey?

A great piece of advice I often come back to is 'identify the problem'. As building a business often feels like non-stop problem-solving and overcoming roadblocks, it helps to be skilled in working out what the problem really is. I find that sometimes I'm getting frustrated with something that is actually just a symptom. A great example of this is that old chestnut we all tell ourselves, 'I don't have time'. The actual problem might be lack of motivation, lack of organisation, or just not having broken down the task into smaller ones that can be accomplished in small windows of time when they come up. When you identify the real problem it becomes much easier to solve.

Finally, what legacy do you want CULTIVER to have?

I'd love CULTIVER to continue as a brand that is relevant – harder than it sounds, as brands need to continually evolve to stay in step with the market and their followers.

cultiver.com

◎ @cultiver_goods

Do you really want to be in business?

PAGES 223–227

Most small business owners I know have a love-hate relationship with social media. One of my clients refers to it as 'a cultural tax everyone in business has to pay'.

Despite the challenges that surround it, social media can be an incredible source of positivity and inspiration.

Case in point: a few years ago I posted a quick Instagram story suggesting that 'people who run their own business are not *better* than people who are employed. Some are suited to operating a business, others are better suited to being an employee. One isn't better than the other.'

I posted it, scrolled, replied to some comments, then put my phone away.

A few hours later when I opened Instagram, I was inundated with direct messages, with the majority full of gratitude for the post.

One woman wrote:

Hi Fiona,

*I don't know you but I wanted to write and say thank you for today's post. For the last two years I have been battling this need to start my own business, even though I'm happy where I am (employed as a lawyer). I feel I'm being shamed for staying in an employed role when the 'laptop lifestyle' is omnipresent. Your post made me feel I could exhale for the first time in months. I like where I work – as an **employee**. I like the security. I like working for a large company. I like being surrounded by people who like that too. I don't want to own a business and that doesn't make me less ambitious than my friends who do. Thanks for listening – K*

It may seem odd to have a chapter in a book about building 'a biz you love' that's dedicated to, well, *not* building a business … at all.

We live in incredible times where anyone and everyone can start a business. All you need is access to the internet, a basic landing page or social media account and off you go. But just because you can, doesn't always mean that you should.

Not everyone is cut out to be in business, and that's entirely okay.

Perhaps you have worked through this book and now you're feeling uneasy; something about the whole idea of growing the business you own, or starting the business you thought you wanted to, doesn't seem as appealing as you'd first thought.

Sometimes understanding who you are *not* is as important as understanding who you are.

Take a minute to consider if a small business is really something you want.

If your small business completely fails and you're forced to seek out an employed role again, how will you feel?

If your answer is more 'annoyed that I wasted my time' and less 'happy that I gave it a go', then perhaps running a small business isn't for you.

While there are a LOT of uncertainties involved in running a small business, there are also some things that are guaranteed:

You will fail.

You will make mistakes.

You will spend money you didn't need to. Probably way more than you thought you would.

You will say something that shines a big ol' spotlight on the fact that you don't know something you should.

You will doubt yourself.

You will cry.

You will feel compelled to justify why you do what you do to well-meaning family and friends (as well as complete strangers).

You will swim (read: drown) in the comparison river from time to time.

You will experience ALL the moods in one day (particularly when you're about to launch something).

You will discover parts of yourself you hadn't ever had to before.

You will wonder why on earth you have chosen to do this.

If you are able to not only cope with the uncertainties listed opposite but also use them to strengthen your resolve and learn from the experience, then small business may just be for you.

If any part of it shook you to your core and had you screaming, 'Let's not. Please,' then consider whether this is the right path for you right now.

Take a minute to think about your 'why' again.

Do you really want to *help* people through what it is your business offers?

I have witnessed waaay too many people start a business purely to make money. At the first sign of financial hurdles, they give up because there isn't a burning desire to keep going. They never discovered their 'why', and when the idea of quitting came up, the question of 'why not?' was too hard to ignore.

Action

Take a few minutes to reflect on how you feel about running a small business *right now*.

 Then answer the following questions in as much detail as you can.

1. If your small business completely fails and you're forced to seek out an employed role again, how will you feel?

2. *Why* are you in business?

3. Is any part of your desire to run a business the result of needing to prove you can to anyone apart from yourself?

4. Are you doing something you love or doing something you think you should love?

5. What do you want your legacy to be and how does your business tie in with this?

6. Do you really want to be in business?

Resources
and tools

PAGES 229–233

If you've made it this far, you may be feeling slightly overwhelmed by how much there is to do. Exhale. In this era of online errrythang, there's a tool or app that will help you plan, execute and analyse.

Here are some of the best resources I recommend to clients and students:

Project planning

These tools are great for everything from mapping out your revenue streams to streamlining your systems and processes.

Mindmeister
mindmeister.com
This is a fantastic digital tool for creating a mind map – basically a brain dump of everything to do with a certain task, project, idea or campaign. For some of your larger tactics or goals, you may wish to start by using this tool.

Asana
asana.com
An awesome tool for managing projects, content and basically anything else you can think of. My team and I use this on a daily basis to keep track of tasks, projects such as website updates and audits, and so much more. It's simple to use with loads of tutorial videos to help you if you get stuck.

Trello
trello.com
Much like Asana, Trello is another online project management tool. I use this for all of my coaching clients, as I'm able to add in goal cards and attach relevant information, tasks and worksheets. We then communicate via the comments section between coaching sessions.

Pinterest
pinterest.com
As a visual person, I find Pinterest a godsend for creating mood boards on everything from branding ideas for clients through to photoshoot ideas for my own business. (Check out my free Pinterest board ideas at pinterest.com.au/mydailybizcoach.)

Instagram
instagram.com
I admit I have a love–hate relationship with social media. I understand the damage certain aspects of it have caused, but I also understand the connection it brings people, particularly small business owners who have been able to grow their business by networking and collaborating with people they may have never met IRL. I am in the DMs daily, chatting with clients, students, friends etc.

Upwork
upwork.com
I work with many microbusinesses and solo operators who don't always have a budget to hire full-time staff. Upwork allows you to find staff around the world for ad-hoc jobs such as website development, social media management, admin and much more. You get to see reviews on staff before you hire, and you can even contact their past clients for more information. My current team have all been sourced from Upwork. They charge normal rates (for the US/UK) and are really experienced in areas I'm not. I also love that I'm helping them reach their biz goals by employing them in my biz.

Content creation

The following tools help you tame the content beast.

Answer the Public
answerthepublic.com

Have you ever wondered about the most common questions people use to search for a product or service like yours? This awesome SEO tool allows you to input a subject (such as 'coffee'), then click to see the top questions related to this topic, along with the current best-ranking website answer. You can download your findings into a CSV file, making easy work of potential blog, video or podcast topics.

BuzzSumo
buzzsumo.com

If you're creating a lot of content, or are just keen to see which content performs best on which social media platform, check out BuzzSumo. An aggregator of online content, it highlights the most popular or engaging articles on any given topic. It's also a great place to find expert authors for particular topics.

Canva
canva.com

This is a simple to use drag-and-drop graphic design tool. I use this multiple times a day. Canva boasts hundreds of templates for everything from social media images and logo designs through to speaker presentations and event invitations.

Google Alerts
google.com/alerts

Do you regularly report on a subject, such as 'mental health' or 'new parenthood'? Google Alerts allows you to track the latest news, blogs and other articles on your search term. You can filter by region and source (i.e. news sites only), and you will receive a snippet of these straight into your inbox. Saves a *whole* lot of research time. It's great to set up for brands/people you wish to collaborate with ahead of sending your initial connection request.

Grammarly
grammarly.com

Bad grammar breaks attention. Don't let your audience lose concentration because of misspelling or incorrect grammar. This tool helps you ensure your content is clear and grammatically correct.

Headline Analyzer
coschedule.com/headline-analyzer

For anyone sending emails, writing blog content or advertising copy, this is a must-use tool. You enter in your headline and it gives you instant feedback with a score out of 100. I always aim for seventy-five or more, and have seen a massive change to my open rates over the years by using this to check subject line ideas.

Hemingway App
hemingwayapp.com

Not so great with words? This tool lets you paste in your text and see where you could improve, suggesting sentences you could make clearer, shorter – or remove altogether.

Unsplash
unsplash.com

A great bank of royalty-free hi-res images that's updated regularly by photographers around the world. Note, once you start using this you'll suddenly realise how many other businesses use it too. I see these images on so many creative agency websites, and have even spotted them in bus stops for health insurance.

Accountability and networking

It's one thing to plan, quite another to execute. These tools will help you stay accountable.

Accountability email

mydailybusinesscoach.com/accountability-email

I send a monthly email to people who want to stay accountable to their goals. You can subscribe to this free tool at the link above.

Closed Facebook groups

With more than 600 million Facebook groups out there, there's something to suit every niche and industry. If you're a designer, it could be a group like Design Therapy, whereas if you're a mum starting a business, it could be the Mums with Hustle biz club.

Meetup
meetup.com

Create your own accountability circle or mastermind by using Meetup to find like-minded biz owners.

Tomato-Timer
tomato-timer.com

I use this every single day to compete with myself. A basic webpage, this nifty tool, based on the Pomodoro method, features a timer to count you down in twenty-five-minute periods, with the option of a five- or ten-minute break. Perfect for giving yourself a deadline and then literally trying to beat the clock.

Physical tools

I was the last generation to grow up without the internet; it launched (in Australian households) at the end of my final year of high school. So when it comes to tools for my small business, I rely on physical ones as much as digital. Plus, sometimes it's nice to get off a screen. Here are the physical tools I use daily.

Mini memo board

I use a mini memo board to list the three key priorities for that day. I also bring it to live workshops so I can amend the agenda according to any time constraints. I've also used it while presenting talks, to remind me of my key points. Basically, it travels everywhere with me.

Monthly whiteboards

I have three monthly whiteboards hung on nails above my desk, showing a quarter of the year at a time, i.e. January, February and March. When one month finishes, I simply move the other two along and add in the next month (i.e. the January board is replaced by April). I have a digital calendar, but I find this makes it so much easier to visualise my availability and key priorities over the next quarter. And, being a whiteboard, it's far easier to update than printed versions.

Annual wall calendar

I have a large full-year wall calendar in my office. It allows me to see the big things coming up, as well as holidays and conferences that may pull me away from work. (One of my clients designed his own and I keep telling him he should start selling it, as it looks awesome.)

Goals diary

As I said before, I love having a physical reminder of what's coming up. I use the Goal Digger Planner from Aussie stationery brand (and one of my clients) Mi Goals. I like this as it's chunky but small enough to fit in my bag. I also enjoy creating my vision board in the front during the summer break.

Podcasts

Years ago I worked at Audible in the UK. At the time we were trying to figure out how to change people's perception and believe that listening to audiobooks or talks wasn't just something 'old people' did. Today, with everyone being a podcast addict, that seems almost laughable. I listen to podcasts *all the time*. Here are ten that I have on rotation.

1. The Pitch – Gimlet

2. How I Built This – Guy Raz (NPR)

3. On Being – Krista Tippett

4. Ask Pat 2.0 – Pat Flynn

5. Unstyled – Refinery29

6. Marketing School – Neil Patel, Eric Siu

7. TDF Talks – The Design Files

8. Routines & Ruts – Madeleine Dore

9. Building a Story Brand – Donald Miller

10. My Daily Business Coach – Fiona Killackey (me!)

Your
mindset

Remember my 2009 stint in London, applying for all of those jobs? During that period we would regularly have friends over for dinner and I would feel like such an idiot having to admit that no, I *still* did not have a job.

One Friday evening, before another dinner party at our place, I received a phone call telling me that despite 'another fantastic final round interview' the company had decided to go with another candidate, one who had 'years of UK experience'. I was gutted, and walked out of the house to gather my thoughts before our friends arrived. When I returned home, my husband had left a little handwritten note on the bed for me. It simply read: 'I believe in you'.

It's amazing and wonderful to have others believe in you (and I know how lucky I am to have such a supportive husband), but ultimately it is YOU who needs to believe in you. You need to believe that you can, and will, make things happen in your biz.

It is YOU who needs to ensure you put the time in to work out what you most want, who you will most serve, what you most want to be known for and how you will make it happen.

Your mindset will be the maker – or breaker – of your business. Your mindset will make the journey between where you are now and where you want to be an adventure or an ordeal.

As I often tell my sons, you are in control of how you view the world around you.

As a small biz owner, you can rush headfirst into #hustle territory, or you can use everything you have learned in this book to create your own path, make things happen that really mean something to you and, ultimately, build a business you love.

I wish you every success on your journey.

Acknowledgements

This book is a result of the experiences, education and entertainment I've enjoyed throughout my career working with some of the most brilliant people on the planet. To those I have worked with, taught, coached, mentored and managed, thank you. I am fortunate to have the most incredible, creative and compassionate clients. To each of you, thank you for trusting me with your business, for being open and willing to take my advice on board and for helping my own growth as a fellow small business owner.

Thank you also to Michael Webster and Tracy O'Shaughnessy, who helped me move an idea for a book into positive action towards making it happen.

To the Hardie Grant family, who have helped me realise my dream of getting a book published; I couldn't be more appreciative. Thank you for your widsom, ideas, patience and advice. In particular, a massive thank you to Roxy Ryan, Pam Brewster, Loran McDougall, Vanessa Lanaway, Hannah Schubert, Michele Perry, Jessica Lowe and Hannah Ludbrook. Thanks also to Andy Warren for bringing this text to life with your brilliant designs.

To the wonderful creative small biz owners who agreed to be profiled in this book and who have impacted my own business over the years – Josh Rubin, Phoebe Bell, Laurinda and Fatuma Ndenzako, Nick Shelton, Marawa Ibrahim, Henrietta Thompson, Ali Kamaruddin, Lucy Feagins, Dhiren Das, Amy Anderson O'Day and Nicolle Sullivan – my sincere thanks. Thank you also to Vy Bhagwandas, Bryranna Sandercock, Eoin Killackey and Sinead de Gooyer for your support and enthusiasm.

To my beautiful small business owner friends, who have shared ideas, contacts and experiences with me that have helped me shape and grow my own business – you know who you are. Thank you.

To my biz besties who listened to my fears and concerns about writing this book and gave me constant and enthusiastic encouragement – Natasha Ace, Paul Darragh and Madeleine Dore – your friendship and counsel means so much.

To my wonderful mother-in-law, Patricia Rebeiro, and our nanny, Louise Tingate, two incredible women who helped me physically write this book by taking care of baby Elio, every week. You helped me move through any mum guilt and pursue my own goals as a woman and business owner. Thank you, thank you, thank you. It's your generation who has paved the way for so many in my generation to be able to do what we do.

Thank you to my extraordinary parents, Frank and Carmel Killackey, who both led by example and sacrificed so much so that myself and my siblings could do anything and everything we dreamed of when it came to our careers. I am so lucky to have had not only great parents, but great friends in both of you. Mum, you showed us all that women really can do anything and that your career does not stop once you become a mother. Dad, your unwavering optimism and belief in the seemingly impossible has helped me more than you could ever know. I miss you both every single day.

The deepest of heartfelt thank yous to my two sons, Levi and Elio, who were the catalysts for me starting my own business and who remind me daily why I do what I do. Lastly, to my magnificent husband, Jerome Rebeiro, who indulges my crazy ideas, believes wholeheartedly in me and provides never-ending wisdom and guidance. You are simply incredible. Thank you.

About the author

Fiona Killackey is the founder of My Daily Business Coach, a consultancy that provides business consulting, one-on-one coaching, group coaching, branding and marketing workshops, online courses, ebooks and creative ideation.

Her clients include Etsy, Australia Post, L'Oreal, AMEB, and various government departments, as well as a host of creative small businesses such as Peachy Green, Indian Goods Co, So Frenchy So Chic, OK Motels, Timbermill, CULTIVER, The Design Files, Købn, Mi Goals, Anaca Studio, Piece Collectors and many more.

Prior to starting her business, Fiona was Head of Marketing at MIMCO (Country Road Group), and before that worked as Audience Engagement Manager at Portable Studios. Between 2009 and 2013 she lived in London, working for Open University on their MBA program and at Amazon UK, where she headed up marketing and content for the entire Kitchen and Home category. Fiona later worked for Audible UK and consulted on their launch into Australia.

In addition to these roles, Fiona has worked as a full-time magazine editor, book editor, writer and ghostwriter. She was a weekly columnist for Fairfax newspapers (2007–2009) and has written for numerous publications across the UK, US, NZ, Australia, Japan and UAE, including, but not limited to, *Monocle*, *Refinery29*, *Nylon*, *Cool Hunting*, *The Design Files*, *The Age*, *Broadsheet*, *The National* newspaper, *Russh*, *frankie*, *Yen*, *CLEO*, *Marketing Magazine*, *SOMA*, *Shift Japan*, *Lunch Lady*, *Sunday Life*, *Flux*, *Slash* and *The Sydney Morning Herald*.

Fiona is also a guest lecturer for General Assembly, RMIT and JMC Academy.

She lives in a log cabin in Warrandyte with her husband and their two young sons.

You can connect with Fiona over on Instagram @mydailybusinesscoach.

Photo © Caitlin Mills

About My Daily Business Coach

My Daily Business Coach is a consultancy based in Melbourne, Australia, that helps business owners (and their teams) understand, create, analyse and improve their business systems as well as their marketing, branding and content strategies. The business was founded by Fiona Killackey in 2015.

Fiona was raised by incredible parents who promoted education and kindness as two of the most important facets of life. It's these beliefs that fuel My Daily Business Coach – which offers free education via Instagram posts and an insightful weekly email, as well as affordable public workshops, ebooks, online courses, business coaching and custom consulting packages. Fiona is also a regular speaker on small business, marketing, content and brand, and has spoken at events for Shopify, Etsy, CreativeMornings and Life InStyle.

My Daily Business Coach treats our incredible clients and customers (many of whom are creative small business owners) with respect and kindness (#OneLove), which is why 98 per cent of our work comes through referrals and recommendations.

Feel free to reach out to us at any time
via email hello@mydailybusinesscoach.com
or send us a DM via @mydailybusinesscoach on Instagram.

mydailybusinesscoach.com

 @mydailybusinesscoach

Published in 2020 by Hardie Grant Books,
an imprint of Hardie Grant Publishing

Hardie Grant Books (Melbourne)
Building 1, 658 Church Street
Richmond, Victoria 3121

Hardie Grant Books (London)
5th & 6th Floors
52–54 Southwark Street
London SE1 1UN

hardiegrantbooks.com

 A catalogue record for this
book is available from the
National Library of Australia

Every effort has been made to trace, contact and acknowledge all copyright holders.
Please contact the publisher with any information on errors or omissions.

Passion. Purpose. Profit.
ISBN 978 1 74379 618 4
10 9 8 7 6 5 4 3 2 1

Publisher: Pam Brewster
Project Editor: Loran McDougall
Editor: Vanessa Lanaway
Design Manager: Jessica Lowe
Designer: Andy Warren
Typesetter: Hannah Schubert
Production Manager: Todd Rechner
Production Coordinator: Mietta Yans

Colour reproduction by Splitting Image Colour Studio

Printed in China by Leo Paper Products LTD.

Disclaimer The material in this book is of a general nature, and does not represent
professional advice. Readers should obtain specific professional advice where
appropriate. The author and publisher disclaim all responsibility and liability arising
directly or indirectly from any person taking or not taking action based on the
information in this book.